Modern Currents
in Japanese Art

Volume 24

THE HEIBONSHA SURVEY OF JAPANESE ART

For a list of the entire series see end of book

CONSULTING EDITORS

Katsuichiro Kamei, *art critic*

Seiichiro Takahashi, *Chairman, Japan Art Academy*

Ichimatsu Tanaka, *Chairman, Cultural Properties Protection Commission*

Modern Currents
in Japanese Art

by MICHIAKI KAWAKITA

translated and adapted by
Charles S. Terry

New York · WEATHERHILL/HEIBONSHA · Tokyo

This book was originally published in Japanese by Heibonsha un-
der the title *Kindai Bijutsu no Nagare* in the Nihon no Bijutsu series.

A full glossary-index covering the entire series will be published
when the series is complete.

First English Edition, 1974

*Jointly published by John Weatherhill, Inc., 149 Madison Avenue, New York,
New York 10016, with editorial offices at 7-6-13 Roppongi, Minato-ku, Tokyo
106, and Heibonsha, Tokyo. Copyright © 1965, 1974 by Heibonsha; all rights
reserved. Printed in Japan.*

LCC Card No. 74-76106 ISBN 0-8348-1028-X

Contents

1. Antecedents of the Modern Period — 11
 - The Groundwork for the Modern Age — 11
 - The Spirit of Logic and Empiricism — 12
 - Shiba Kokan: The Occidentalist Type — 14
 - Maruyama Okyo: The Reformist Type — 25
 - Katsushika Hokusai: The Individualist Type — 27
 - The Commingling of the Types — 29

2. The Impressionist School in Japan — 32
 - The Flourishing of "Dutch Studies" — 32
 - Togai's Studies in Western Painting — 32
 - The Realism of Takahashi Yuichi — 35
 - The School of Art in the Technological College — 37
 - The Meiji Art Society and Asai Chu — 39
 - Kuroda Seiki and the Plein-Air School — 39
 - Fujishima Takeji and Aoki Shigeru — 59
 - The Secret Whispering of Nature — 62
 - Romantic Mood and Historical Painting — 64
 - The Relationship Among Fujishima, Aoki, and Takehisa — 73

3. The Tenshin Group and Its Influence 76

 Okakura Tenshin and the New Japanese-
 Style Painting 76

 The Japan Art Academy 78

 Kanzan, Taikan, and Shunso 80

 Taikan and the New Nihonga 83

 Tenshin's Ideals 85

 Taikan and Tessai 88

 Academy Painters of the Second Period 90

 The Kyoto School 91

 An Independent Giant: Tomioka Tessai 93

 Other Influential Painters 94

4. From 1910 to 1925 95

 The Introduction of New European Art 95

 Philosophical and Literary Orientation 96

 The Exhibitions of the Fusain Society 105

 Kishida Ryusei 105

 Influential Artists of the Nika Society 108

 The Fauvist Style in Japan 118

 New Trends in Sculpture 119

5. From Modern to Contemporary 121

 The Crisis After the Great Kanto Earthquake 121

 The Yasui-Umehara Period 122

 The Yukihiko-Kokei Period 124

 Responses to the Social Milieu 127

 New Explorations in Pure Art 128

 Modern Handicrafts and Architecture 132

6. The Lineage of Modern Japanese Art 136

 Nihonga 136

 Yoga 148

 Sculpture 150

 Architecture 153

7. Local Art Museums 154

 Prototypes of Art Museums 154

 The Advent of the Private Collector 154

 Prewar Art Museums 155

 Postwar Art Museums 156

Modern Currents
in Japanese Art

Antecedents of the Modern Period

THE GROUNDWORK FOR THE MODERN AGE

In the general unfolding of world history, the social, political, and economic development of Japan in the hundred years or so since the beginning of the Meiji era (1868–1912) has been a spectacular episode. The very rapidity of the changes that have occurred has concealed a number of concomitant weaknesses and inconsistencies, but the mere fact that a small insular country in the Far East contrived in such a short time to break through the confines of traditional Oriental culture and, with liberal infusions of Occidental elements, to transform itself into a highly industrialized and sophisticated modern nation has made a deep impression upon historians throughout the world.

The purpose of this volume is to trace the development of Japanese art during this eventful century. It would be a mistake, however, to start with the assumption that the modernization of Japanese art began suddenly in 1868. In history there are always halting proto-movements without which periods of striking growth and expansion do not occur. Momentous change may seem to take place all of a sudden, but closer examination reveals that it is invariably preceded by an accumulation of causative forces.

The foundation for modern Japanese art movements was laid in the Edo, or Tokugawa, period (1603–1868). Indeed, the early-Meiji approach to modernization in general had already been expressed one hundred years before Meiji began, and though opinions advocating change had to some extent been muted because of various restrictions imposed by the Tokugawa shogunate, it is clear that the modern Japanese culture of the Meiji era and after began to take form well before 1800 and in some ways manifested itself in a purer state before 1868 than afterward.

In his "Introduction to the History of Japan" in Bradley Smith's *Japan: A History in Art* (New York: Simon and Schuster, 1964), Professor Marius B. Jansen of Princeton University observes: "In short, Japan was in many ways very little 'behind' the Western world in respect to education, nationalism and bureaucratic complexity of government by the time of the nineteenth century. It required only a centralizing effort to make uniform and universally available advantages that were already widespread.

"The influence of the West with its message of progress and industrialization in the middle of the nineteenth century served as a catalyst. There was no automatic or easy transition to modern ways, but the pace was a very rapid one."

In other words, the cultural flowering that followed the Meiji Restoration may appear to have

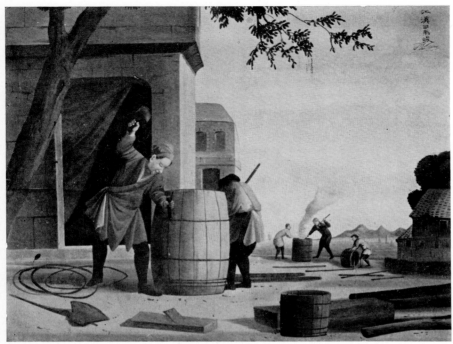

1. Shiba Kokan: The Coopers. *Colors on silk; height, 47 cm.; width, 60 cm. Late eighteenth century.*

had no connection with what went before, but in fact it had as its background a cultural milieu very little less advanced than that of the West at the time. This is amply evident in the realm of art.

THE SPIRIT OF LOGIC AND EMPIRICISM

An influx of Western art was, as one might expect, the catalyst that quickened the pace of post-Restoration art movements, but earlier Japanese artists had already acquired much valuable experience with Occidental art techniques. Even in the Genroku era (1688–1704), the quintessential age of the "floating world," one finds the beginnings of a spirit of empiricism, accompanied by increased interest in the "pure science" of the West. Studies in Occidental scientific methods were spurred on by the desire for more efficient production, by wider scholarship, by the need for better health protection, and, indeed, by governmental encouragement and support, and in the eighteenth century the intellectual achievements of the West were being culled not only in second-hand form from imported Chinese books but also from European writings brought by the Dutch traders in Nagasaki. A whole branch of learning, centered on the more practical sciences, came to be known as *rangaku,* or "Dutch studies."

The celebrated Confucian scholar Arai Haku-seki* (1657–1725), who was an adviser to the shogunate, wrote a book called *Seiyo Kibun* (A Record of Western Matters), and the eighth Tokugawa shogun, Yoshimune (1684–1751), officially encouraged *jitsugaku,* or "practical studies," by which he

* The names of all Japanese in the text are given, as in this case, in Japanese style (surname first).

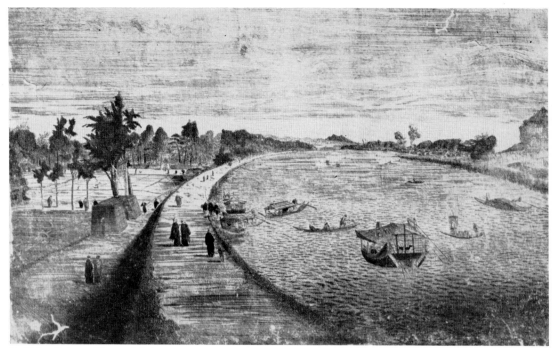

2. *Shiba Kokan:* View of Mimeguri in Edo. *Copperplate etching with colors added by brush; height, 28.2 cm.; width, 40.3 cm. 1783. Kobe City Museum of Namban Art.*

meant the study of Western science. In 1720 the longstanding ban on Western books was lifted, insofar as the books were not related to Christianity, and in general there appeared an ever increasing interest in Western empiric sciences and in Western modes of thinking. From this sprang the first research into Western art.

One of the earliest experimenters was Hiraga Gennai (1726–79), a botanist with what might be called Encyclopedist leanings. Gennai, by producing such semiliteral paintings as *Portrait of a Western Lady* (Fig. 11), not only gave rise to a local school of Western art in the district now known as Akita Prefecture but also furnished inspiration for Shiba Kokan (1738–1818), an artist-scientist who is known today as the most prominent Western-style painter of the Edo period (Figs. 1, 2).

It is important to notice, however, that the influ-ence of Western art in this age extended not only to the science-oriented *rangaku* scholars like Gennai and Kokan but also to painters working in more traditional idioms. A notable example is the Kyoto artist Maruyama Okyo (1733–95), whose *megane-e,* or "eyeglass pictures" (Fig. 14), showing scenes as if viewed through the magnifying lens of a peep show, attempted to make Western realism appeal to the Japanese eye. Another innovator was the great woodblock-print artist Katsushika Hokusai (1760–1849), who, having experimented with Western perspective and realism, went on to create an earthy Japanese-plebeian realism of his own.

Kokan, Okyo, and Hokusai were of differing schools of art, and though each was influenced by Western art, each revealed the influence in a different way. It is interesting to note that the three approaches they represented reappeared as the

3. *Odano Naotake:* Shinobazu Pond. *Colors on silk; height, 98.5 cm.; width 132.5 cm. About 1775–80. Akita Prefectural Office.*

three mainstreams of Japanese painting after the early-Meiji intoxication with Western literalism had worn off.

SHIBA KOKAN: THE OCCIDENTALIST TYPE

As a "Dutch scholar," Shiba Kokan was particularly attracted to astronomy and geography. He was a progressive scholar and thinker who did much to spread knowledge of the Copernican theory and world geography and who argued not only for a return to intellectualism but also for the promotion of trade with foreign countries. His paintings, reflecting his inquisitive, logical spirit, are rooted in empiricism and pure realism.

He laid great emphasis on the practical aspect of painting. In his *Seiyoga Dan* (Discussion of Western Painting), translated by Calvin L. French in his *Shiba Kokan: Artist, Innovator, and Pioneer in the Westernization of Japan* (New York and Tokyo: Weatherhill, 1974), he makes the following observations:

"The primary aim of Western art is to create a spirit of reality, but Japanese and Chinese paintings, in failing to do this, become mere toys serving no use whatever.

"By employing shading, Western artists can represent convex and concave surfaces, sun and shade, distance, depth, and shallowness. Their pictures are models of reality and thus can serve the same function as the written word, often more effectively. The syllables used in writing can only describe, but one realistically drawn picture is worth ten thousand

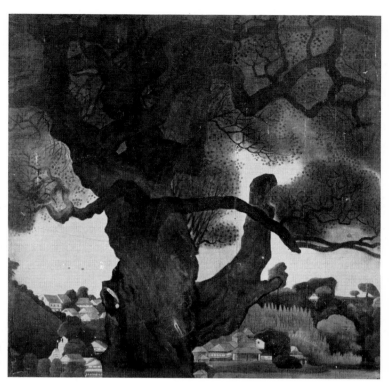

4. Aodo Denzen: View of Tameike. *Oil on canvas; height, 27 cm.; width, 26.4 cm. First half of nineteenth century.*

words. For this reason Western books frequently use pictures to supplement descriptive texts, a striking contrast to the inutility of the Japanese and Chinese pictures. . . .

"Portraiture is an important art form in the West, where the faces of sages and political figures are recorded in copperplate engravings for the benefit of future generations. The portrayal of these men gives one as clear an understanding of their physiognomies as seeing the men themselves. Again, the contrast to Japanese and Chinese paintings is striking, for without the technique of copying reality, the Eastern artist can paint only a subjective impression of an object or a face. The same man, if painted by two different Japanese artists, will appear to be two different men. Consequently, since

the true form is not described, only a vague image appears. An image of grass and flowers that does not resemble the actual plants can hardly be called a picture of them.

"The indigenous art technique of Japan and China cannot possibly reproduce reality. In drawing a spherical object, a Japanese artist will simply draw a circle and call it a sphere because he has no method for representing roundness. Being unable to deal with convexity, should he draw the front view of a man's face, there is no way of expressing the height of the nose! This difficulty is not due to the way in which the lines are drawn, but to the total disregard of shading in Japanese art."

Kokan's comments summarize the attitude of a number of artists whose approach to Western paint-

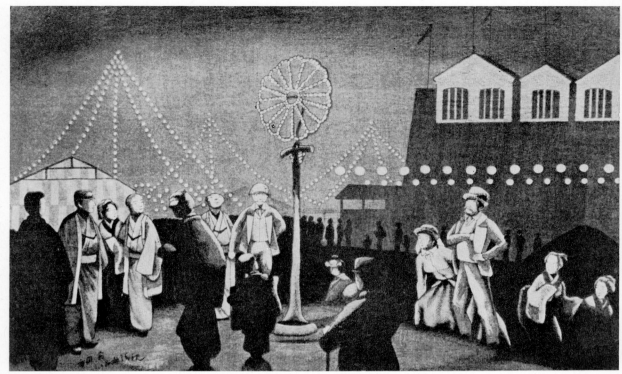

5. Kobayashi Kiyochika: Gas Pavilion at the Industrial Fair. *Woodblock print; height, 24.8 cm.; width, 35.8 cm. 1878.*

ing was primarily empiric and practical. Satake Shozan (1748–85), a member of the Akita group who studied under Hiraga Gennai, also characterized Oriental painting of the past as "frivolous" and "of no use to the country," and both Odano Naotake (1749–80; Fig. 3) and Aodo Denzen (1748–1822; Fig. 4) of Fukushima seem to have shared Kokan's clinical, no-nonsense view of painting, as did a number of artists working in the late Edo period and the early Meiji era.

It is significant, however, that whereas the early advocates of Western art had been moved by a passion for logic and truth to take up the foreign style, as time went by, the inner flame tended to dwindle, leaving only an uninspired Occidentalism. What had been at the beginning a surging effort to

absorb the new became in many instances little more than a process of aesthetic transplantation.

Despite the ardor with which Kokan and his group espoused Western painting, it may well be that if the Western painting they saw had not been representational, they would have turned instead to the study of photographic devices. Their interest was not in beauty but in fact—even commonplace fact. As a result, their studies did not lead to a comprehensive new conception of the world and of life, and for lack of this their painting failed to mature. In his late years, Kokan himself showed signs of abandoning his youthful enthusiasm for science in favor of Taoism, and there are frequent instances in later times in which young Occidentalists, having failed to find a new vision of life, have retreated

6. Ogiwara Morie: detail of Woman. *Bronze; height of entire statue, 98 cm. 1910. Tokyo National Museum of Modern Art.* ▷

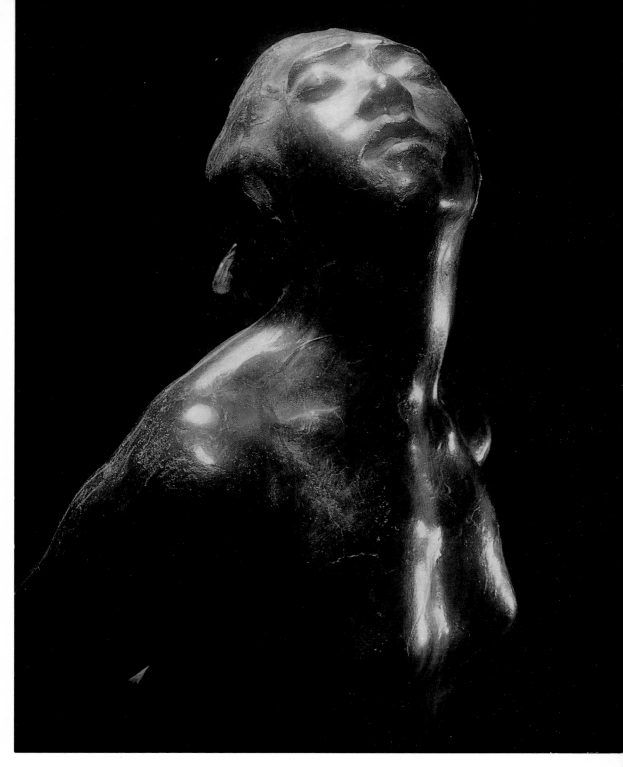

7 (overleaf). Aoki Shigeru: detail from Harvest of the Sea. *Oil on canvas; dimensions of* ▷
entire painting: height, 66.6 cm.; width, 178 cm. 1904. Bridgestone Museum of Art, Tokyo.

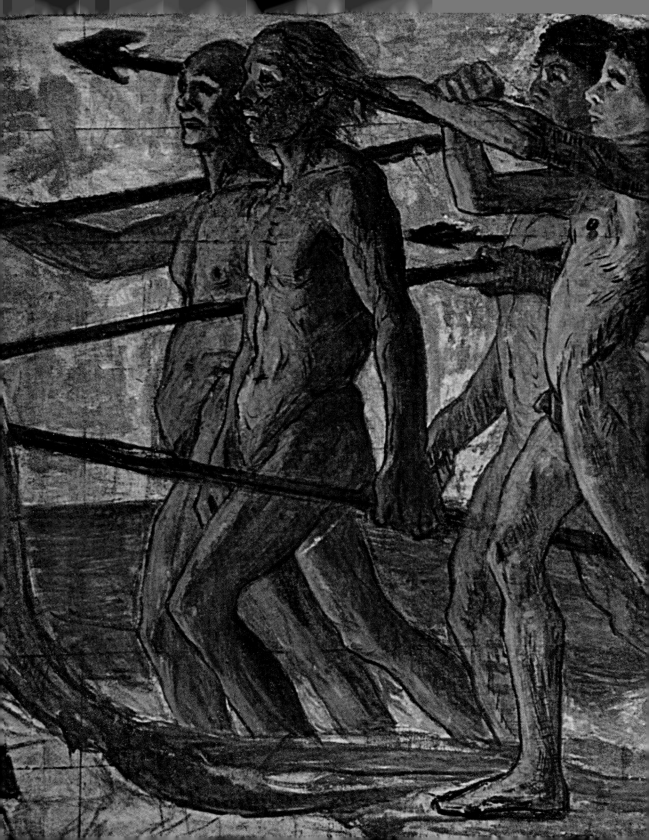

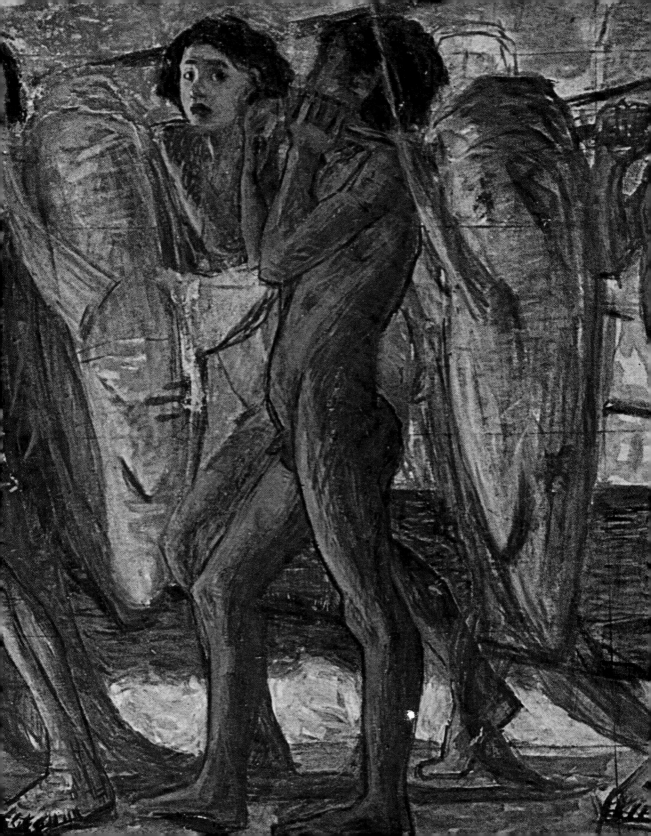

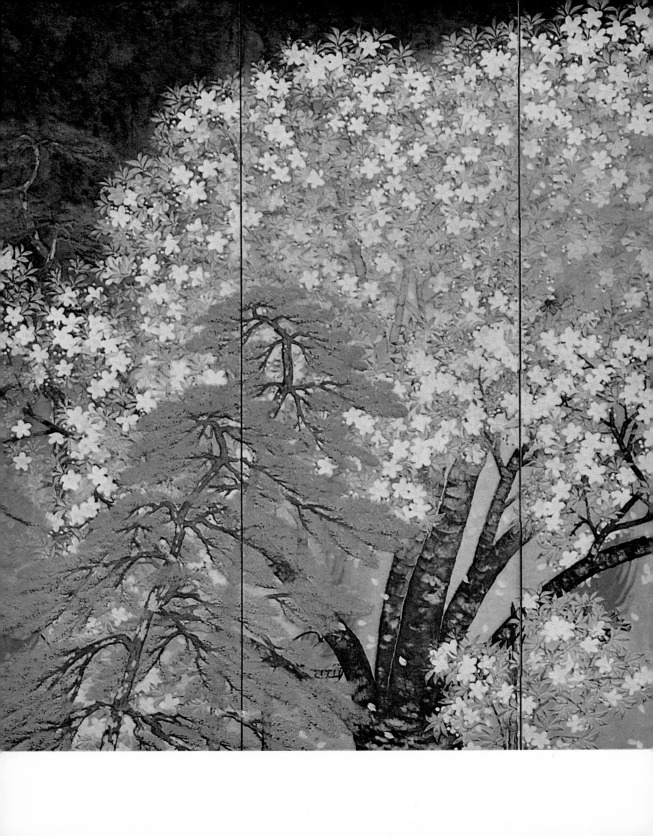

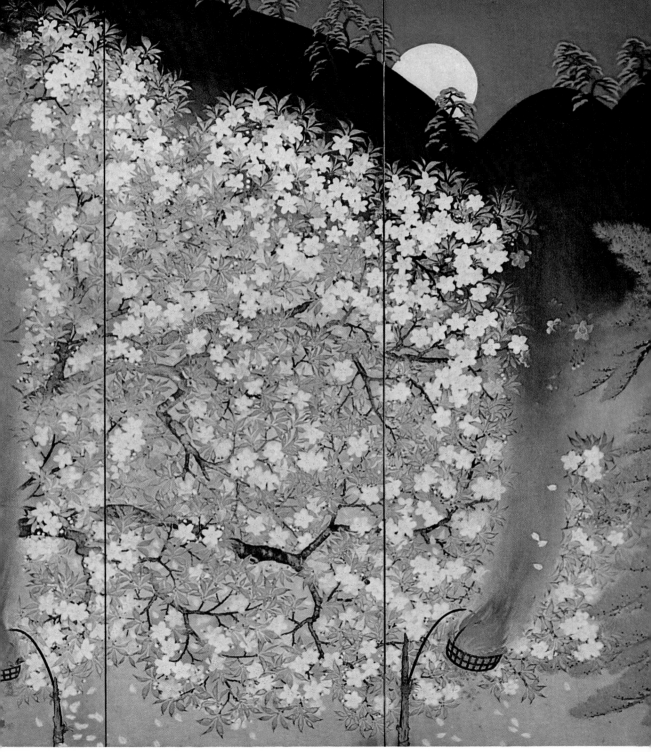

8. *Yokoyama Taikan: detail from left-hand screen of a pair of sixfold screens entitled* Cherry Blossoms at Night. *Colors on paper; dimensions of each screen: height, 177.5 cm.; width, 375 cm. 1929. Okura Cultural Foundation, Tokyo.*

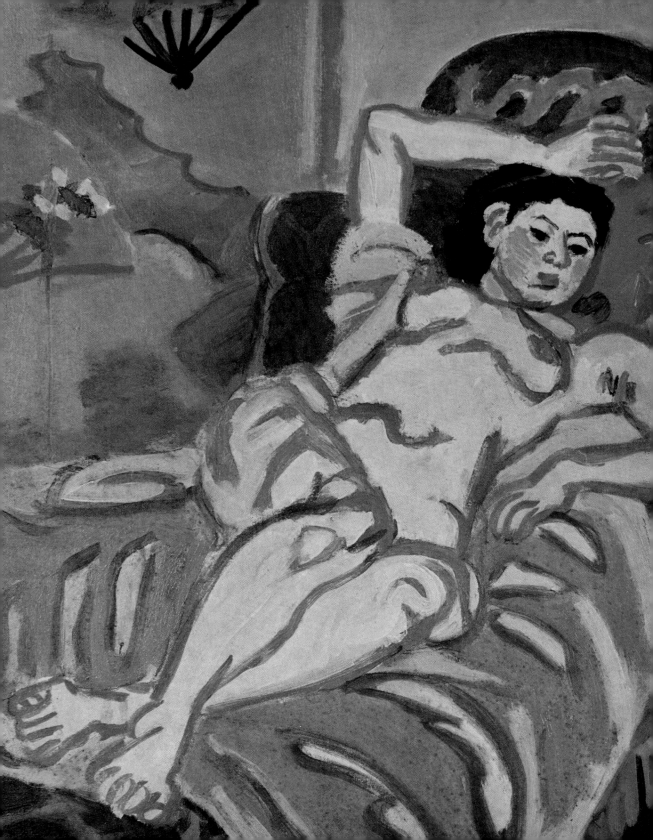

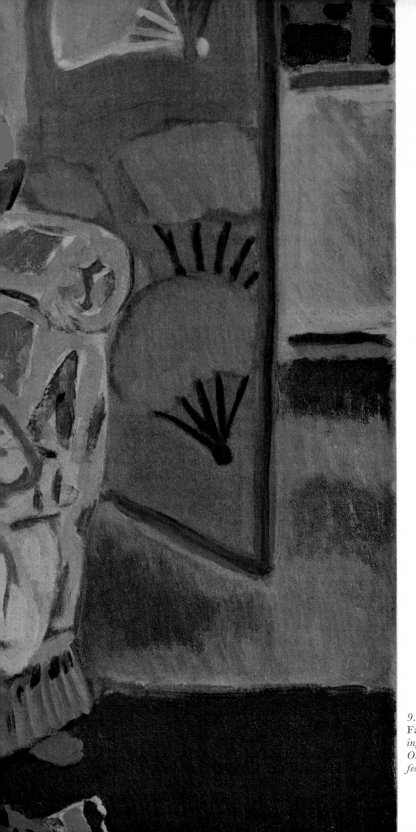

9. *Umehara Ryuzaburo: detail from* Nude and Fans. *Oil on canvas; dimensions of entire painting: height, 81 cm.; width, 65 cm. 1937. Ohara Art Museum, Kurashiki, Okayama Prefecture.*

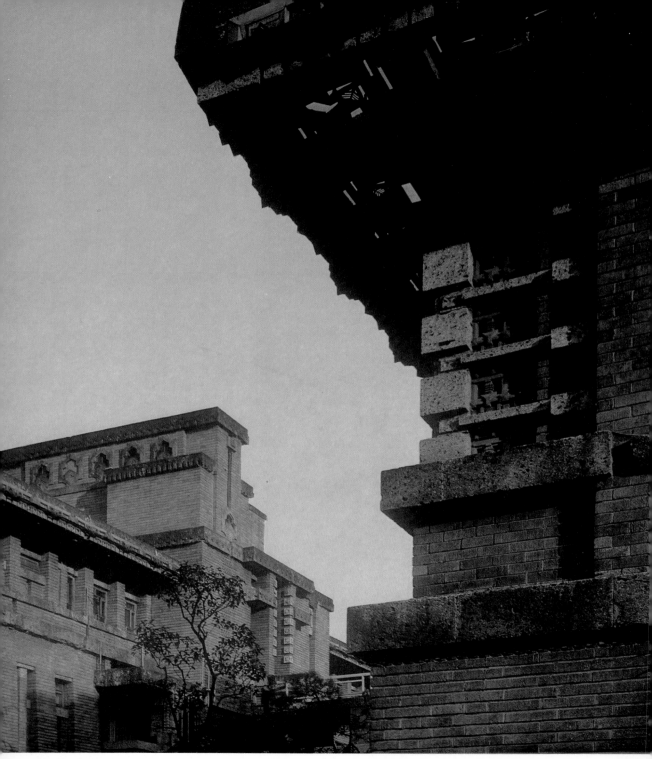

10. Frank Lloyd Wright: Imperial Hotel, Tokyo. 1922. Demolished in 1968. (See also Figure 140.)

11. Hiraga Gennai: Portrait of a Western Lady. Colors on hemp cloth; height, 45.1 cm.; width, 33.6 cm. Mid-eighteenth century. Kobe City Museum of Namban Art.

in their later years to Oriental patterns of thought. Perhaps this tendency is implicit in the Occidentalist type.

MARUYAMA OKYO: THE REFORMIST TYPE

When one considers how vast the influence of Maruyama Okyo and his followers has been on subsequent Japanese art, it is difficult to avoid the conclusion that their appearance on the scene must have been a historical necessity. Okyo is said to have told his followers: "If you do not sketch the true thing at first hand and then make it into a new picture, what you have done is not worthy to be called a picture. Grandeur, boldness, grace, and elegance come into consideration only after you can sketch a form accurately and maturely. They are not achieved by

the hands alone. For this reason, beginning students may be clumsy with the brush, but they must put their whole hearts into understanding the structure and the idea. The decline of painting in recent times is a result of copying paintings of the past. Artists today are shamelessly copying old works and then affixing their own signatures and seals, as though the works were their own. They tend to disapprove of new ideas and instead just go on playing idly with their brushes and ink."

As this indicates, Okyo resembled Shiba Kokan in disapproving of traditional artists of his time and in laying great stress on the importance of true-to-life sketching. Where he differed from Kokan was in his effort to incorporate Western ideas into traditional art and thus reform and improve the latter.

Even as a child, Okyo displayed remarkable tal-

ent as a painter. He studied the prestigious Kano style with Ishida Yutei (1721–86) and distinguished himself for his competence and originality in the use of traditional brush techniques. To help support himself, he drew the *megane-e,* or eyeglass pictures, referred to above. These were pictures drawn by the projection method and originally intended to be viewed through a camera obscura, which device had been imported into Japan in the late seventeenth century, probably by way of China. The camera-obscura pictures from Europe inspired a whole school of prints in China, and they were also imitated by Japanese print artists such as Okumura Masanobu (1686–1764).

Okyo at first copied models from China but gradually mastered the principles on which they were based, including the fine, sharp linear treatment of Dutch copperplate engravings, which were the source of the style. He produced a series of *megane-e* on scenes in Kyoto that was later trans-

ferred to wood blocks and reproduced in quantity.

The next step was to try to incorporate the logic of realism into the traditional style, and this is what Okyo attempted to do in such works as *The Two Banks of the Yodo River* (Fig. 12). As he grew older, he added to his style more elements from Chinese painting of the Sung and Yuan periods (960–1368), developed new methods of sketching, and even incorporated characteristics of the Japanese decorative school, but his most basic contribution to the art of later times was his fusion of Western realism with Oriental tradition. There is no denying that this fusion came off better in Okyo's sketches and small works than it did in his larger paintings, many of which are rather insipid, but the mere effort to improve upon tradition and to create a new style set a trend that has remained important in Japanese art ever since. Watanabe Kazan (1793–1841; Fig. 17) pursued the same course in the late Edo period, and since 1868 numerous important artists have at-

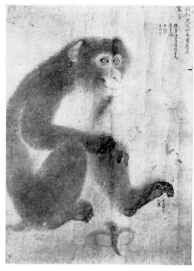

12. *Maruyama Okyo: detail from a hand scroll entitled* The Two Banks of the Yodo River. *Colors on silk; height, 42 cm. 1765.*

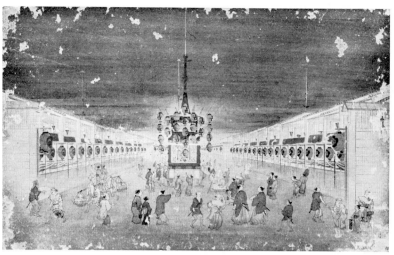

14. *Maruyama Okyo:* Festival. Megane-e *(eyeglass painting); colors on paper; height, 24.1 cm.; width, 36.5 cm. About 1760.*

13. *Maruyama Okyo:* Monkey, *from a hand scroll entitled* Realistic Sketches. *Colors on silk; dimensions of entire scroll: height, 44.2 cm.; length, 278 cm. 1770.*

tempted to broaden Okyo's basic approach. These men include not only the Kyoto artist Takeuchi Seiho (1864–1942) but also leaders of the well-known Japan Art Academy, such as Yokoyama Taikan (1868–1958), Shimomura Kanzan (1873–1930), and Hishida Shunso (1874–1911).

One of the principal goals that modern Japanese artists have aimed at is the satisfactory amalgamation of realism with the decorative style of the past. This effort can be traced straight back to Maruyama Okyo, marking him as one of the chief precursors of present-day Japanese art.

KATSUSHIKA HOKUSAI: THE INDIVIDUALIST TYPE

To single out Hokusai as an individualist is perhaps unfair to others, because any artist worthy of the name has some degree of individualism. Still, in a period when one group of artists was accepting Occidental influences more or less in toto and another group was attempting to fit them into the Oriental tradition, Hokusai stands out as an eccentric. He neither made a great point of emphasizing Western elements nor took a strong stand in favor of tradition. By the same token, he was able to employ both Occidental and Oriental devices in arriving at the result he himself desired (Fig. 18).

In the afterword to his *One Hundred Views of Fuji*, he wrote: "Since I was six years old, I have had the habit of drawing the forms of things, and since I was fifty I have drawn many, many pictures, but nothing I drew before I was seventy was of any value. At seventy-three I have caught a glimpse of the bone structure of birds, fish, animals, and insects, and of the life force in plants and trees. When I am eighty, I shall have advanced further, and when I am ninety I shall have better understood the deeper meanings. Perhaps by the time I am a hundred I shall have mastered the secrets, and

 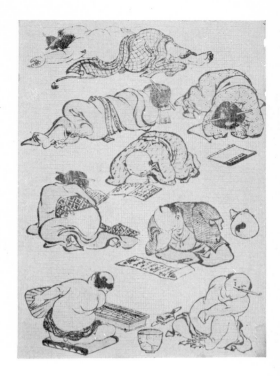

when I am a hundred and ten, every dot and corner I draw will be full of life. I only hope that the Lord of Long Life will not let these words come to naught."

Signed "The Old Man Crazy About Art," this is a classic statement of one who has chosen art as his way of life. And the remark about having had the habit of drawing since the age of six suggests that he had already determined his own position before being exposed either to Western art or to Oriental tradition.

Hokusai's realism coincided with the movement toward logic and empiricism, but it was instinctive rather than studied, plebeian rather than scientific. The reality that he sought was not to be achieved merely by using the logical methods of Western painting. Hokusai experimented with projection

and perspective in his youth, but at the same time he was busily engaged in drawing light, sometimes comic, illustrations for novels. He aimed at a reality that was closer to the feeling of true life than mere realism—a reality in which one would see not only "the bone structure of birds, fish, animals, and insects" but also vitality and life in "every dot and corner." His ideal of realism was one in which the logic of the West became indistinguishable from the grace and spirit of the East.

Hokusai was an eclecticist par excellence. To the ukiyo-e he added Western features, and to these he in turn added elements from the ink painter Sesshu (1420–1506), from the Kano school, from Ming and Ch'ing painting, from *yamato-e* (indigenous Japanese painting), and from traditional Japanese realism. But he brought them all together in a style that

◁ *15 (opposite page, left). Katsushika Hokusai:* Mishima Pass in Kai Province, *from the seventh volume of the* Hokusai Manga *(Hokusai Sketchbooks). Ink on paper; height, 18 cm.; width, 12.5 cm. 1817.*

◁ *16 (opposite page, right). Katsushika Hokusai:* Postures by the Crazy Painter Katsushika, *from the eighth volume of the* Hokusai Manga *(Hokusai Sketchbooks). Ink on paper; height, 18 cm.; width, 12.5 cm. 1818.*

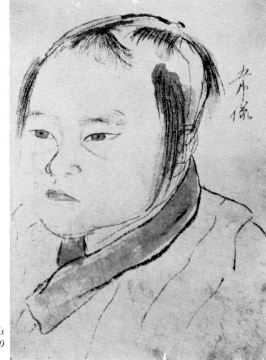

17. Watanabe Kazan: sketch for a portrait of his younger brother Goro. Colors on paper; height, 20 cm.; width, 14.2 cm. 1821.

could hardly have been more individualistic, freely combining landscapes with human figures and portraying the very essence of all that he saw (Figs. 15, 16). He wrote: "Shading in European painting and shading in Japanese painting are as different as front and back. In China and Japan . . . shading is conceived of in the same way as patterns or designs and may be accompanied by patches of gold. The intent is not to show three-dimensionality. One must understand both methods: there must be life and death in everything one paints."

If one thinks of Chinese and Japanese shading as a form of patterning or design, then realism can be developed only in movement and liveliness, but in European painting the realism appears on the surface of the objects painted. It is a question of whether one approaches realism in a dynamic way or in a static, empiric way, but each approach has its advantages and disadvantages. Hokusai instinctively felt that any method—the Oriental or the Occidental, the theoretical or the traditional—could be used so long as the effect was to put life and death into the painting.

THE COMMINGLING OF THE TYPES Any artist must to some degree have the independence of spirit that Hokusai exemplified, and in general the extent to which artists of the Occidentalist type and the Reformist type succeeded can be measured by the degree to which they approached the Individualist type.

The very fact that Western art was the catalyst that hastened the development of modern Japanese

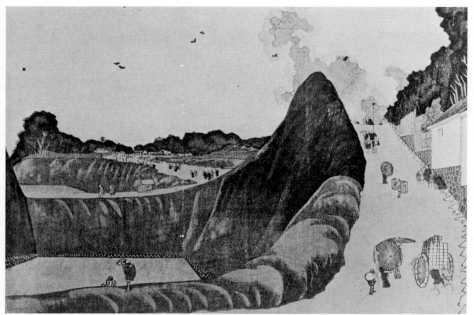

18. Katsushika Hokusai: Ushigafuchi in Kudan. *Woodblock print; height, 18.4 cm.; width, 24.7 cm. Early nineteenth century. Tokyo National Museum.*

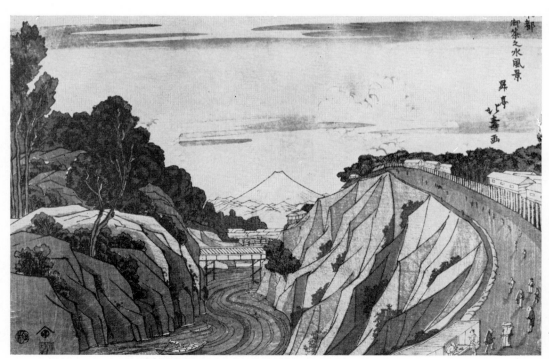

19. Shotei Hokuju: View of Ochanomizu in Edo. *Woodblock print; height, 24.5 cm.; width, 38.8 cm. Early nineteenth century. Tokyo National Museum.*

art meant that artists had to choose between pursuing Western methods wholeheartedly and trying to fit them into traditional art. The pendulum swung back and forth, and it was difficult for anyone to adopt the purely individualistic path. As a rule, even the most individualistic artists had either an Occidentalist bent or a Reformist bent.

Among the Individualist artists of the Meiji era and after who made their approach through Occidentalism were Asai Chu (1856–1907), Aoki Shigeru (1882–1911), Kishida Ryusei (1891–1929), Sekine Shoji (1899–1919), Sakamoto Hanjiro (1882–1969), Umehara Ryuzaburo (1888–), and Suda Kunitaro (1891–1939). Those who made their approach as Reformists included Hishida Shunso (1874–1911), Hayami Gyoshu (1894–1935), Murakami Kagaku (1888–1939), and many other painters of the neo-Japanese-style school.

The commingling of the three types outlined above has been one of the dominant trends in modern Japanese art. Each type represented a train of thought that led to new vistas of art, and the intertwining of the three led to an immense variety of styles and genres.

CHAPTER TWO

—◆—

The Impressionist School in Japan

THE FLOURISHING OF "DUTCH STUDIES" If one takes the term "impressionist" in its strictest sense, it is questionable whether an impressionist school has ever existed in Japan, for one will search in vain for the type of work that Monet and his colleagues accomplished in Europe. Still, the influence of the plein-airists and the French impressionists on modern Japanese art has been tremendous, and it was an impressionist-oriented Japanese artist, Kuroda Seiki (1866–1924), who laid the foundation for the twentieth-century development in Japan of Western-style painting. Consequently, it is convenient to speak of a Japanese impressionist school in reference to a large number of painters whose style can be traced back ultimately to French impressionism.

The Western-style painting of the Meiji era, however, did not begin with Kuroda and the impressionist influence. On the contrary, the earliest Western painting of the era traces its lineage back to the Occidentalists of the Edo period.

During the first quarter of the nineteenth century, "Dutch studies" reached a high level, partly as a result of the efforts of the Dutch naturalist Siebold and other visitors from abroad to train Japanese followers. As the seeming threat of incursions by foreign countries created a sense of need for modern naval defense, the study of the West was

accorded official status. The shogunate's Bureau of Astronomy was given charge of translating Western books on astronomy, and in 1811 a special office was set up for translating foreign books in general. Among the works translated were Noël Chomel's *Encyclopedia* and several other volumes dealing with subjects far beyond the confines of geography and astronomy. As foreign contacts became more numerous, the translation office was made independent and renamed the Office of Western Studies (Yogakusho). This was in 1855. Only a year later, this institution, now renamed the Institute for the Study of Western Documents (Bansho Shirabesho), became a sort of school of foreign studies for the shogun's retainers and later for clansmen as well. The director of the school was the Confucian scholar Koga Kin'ichiro (1816–84), who was assisted by the physicians Mitsukuri Gembo (1799–1863), Sugita Seikei (1817–59), and other leading students of the Occident. Many Meiji cultural leaders were alumni of this school, and one of them was Kawakami Togai (1827–81; Fig. 20), who became the first important Western-style artist of the Meiji era.

TOGAI'S STUDIES IN WESTERN PAINTING In 1857 Kawakami Togai became what might be called a visiting fellow in painting at the Institute for the Study of Western

20. *Kawakami Togai:* Kayabe Pass in Hokkaido. *Oil on canvas; height, 65.8 cm.; width, 93 cm. About 1877. Imperial Household Agency, Tokyo.*

Documents, and in 1861, when a department of painting was established there, he became its director. His duties were to study Western painting from foreign books and to relay his knowledge to his pupils, who included Miyamoto Sampei, Takahashi Yuichi, and Kondo Masazumi. In 1863 the name of the school was changed to the Kaiseijo, but studies in Western painting continued as before, if not with greater intensity.

Togai's approach to the study of Western art was perhaps not as enthusiastic as it might have been. Even though he was a pioneer in the field of Western painting in Japan, as an artist he apparently preferred the so-called *nanga* style of the pre-Meiji literati painters to the oil painting of the West, and in many ways he could be classified primarily as an early-Meiji *nanga* artist rather than as an Occidentalist.

Having started as a member of the Kyoto school, which traced its origins to Maruyama Okyo, Togai gained a measure of fame as a *nanga* painter, but, according to one biographer, "he saw that times were about to change, and sensing that there was no future other than in 'Dutch studies,' he secretly, but assiduously, set about mastering that field of learning." In other words, Togai entered the school of Western studies not because he wanted to study art but because he thought Western studies were necessary for his future, and when the school established its department of painting, he was given the directorship because of his artistic proclivities. Most likely his studies of Western art were more of a purely practical nature than would be considered appropriate in a modern art academy, but then it should be remembered that his school was not promoting the study of Western art for aesthetic pur-

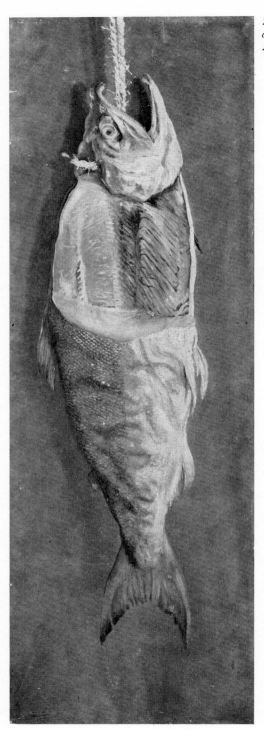

21. *Takahashi Yuichi*: Salmon. *Oil on canvas; height, 139 cm.; width, 46.6 cm. About 1876. Tokyo University of Arts.*

poses. The fact is that Western art, like Western languages and science, was being studied because it was considered necessary for defense and diplomacy as well as for the advancement of architecture and civil engineering.

Togai's record furnishes an interesting sign of the times. In the last years of the Edo period he was sent along with the shogunate's forces to make sketches of the military campaign against the rebellious Choshu clan, and after the beginning of Meiji he became instructor in drawing at the Numazu Military School. Later, as an instructor at the government school of Western studies called the Daigaku Nanko, he was in charge of publishing a geography of the world and a guide to Western painting. Still later he became professor of painting at the Military Academy, at the same time also working in the map department of the Army Gen-

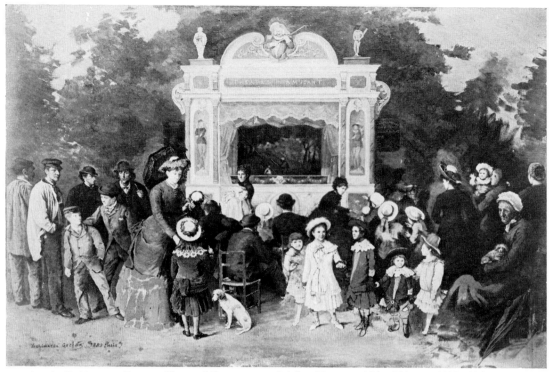

22. Goseda Yoshimatsu: Puppet Show. *Oil on canvas; height, 88 cm.; width, 118 cm. 1883. Tokyo University of Arts.*

eral Headquarters. For pleasure, Togai exchanged *nanga* paintings with his friends, among them Yasuda Rozan (1830–82). Togai was not interested in Western painting as an art. He saw only its techniques and its practical aspects. The truth is that in Togai's time Western painting was not considered by the Japanese to *be* an art.

How this "nonart" came to be accepted and admired as art in Japan is the history of Western painting from the time of Togai to that of Kuroda Seiki. Landmarks along the way were the careers of Takahashi Yuichi and Asai Chu.

THE REALISM OF TAKAHASHI YUICHI

Takahashi Yuichi (1828–94), who studied under Togai, acquired his interest in Western painting in an entirely different way from that of his teacher. According to an autobio-

graphical sketch, he was born with a love of painting and, as soon as he was old enough, began to study the academic style of the Northern Sung dynasty (960–1126) but around 1850 was converted to Western art by the sight of some European lithographs.

Yuichi wrote: "Around 1850 a friend lent me some Western lithographs to look at, and I discovered that I was interested in the way they portrayed everything so accurately. I immediately decided to study the method, but it was difficult to find anything to study by, and I fretted and fumed night and day for some time. I decided there was nothing to do but ask the government to let me study under a foreigner, but it turned out that the necessary procedures were too difficult. As I was idling away the time, it occurred to me that I might be able to observe Western methods of paint-

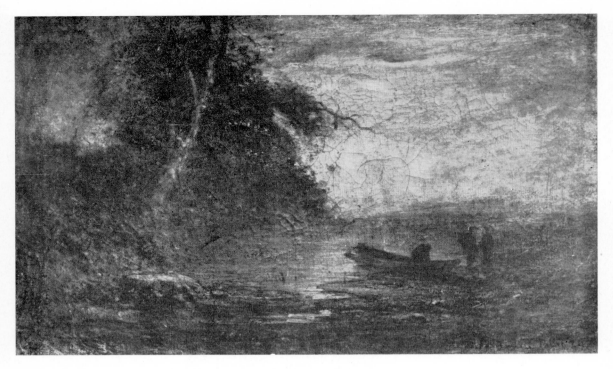

23 (above). *Antonio Fontanesi:* Sunset over
a Marsh. *Oil on canvas; height, 39.5 cm.;
width, 61 cm. 1876–78.*

24. *Koyama Shotaro:* Cowherd. *Water colors; height, 40 cm.;
width, 31 cm. About 1879–80.*

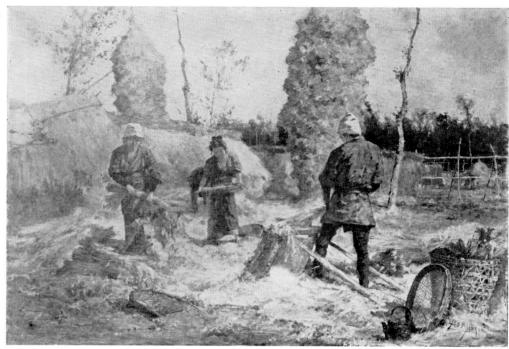

25. Asai Chu: Harvest. Oil on canvas; height, 69.9 cm.; width, 98.8 cm. 1890. Tokyo University of Arts.

ing at the Institute for the Study of Western Documents, which had been established some time before that."

Yuichi's discovery that he was "interested in the way they portrayed everything so accurately" was extremely important. Not only was he surprised by the realism of the lithographs, but he also liked it. Consequently, whereas Togai regarded Western painting as work and took his pleasure in traditional art, Yuichi considered the new painting to be art as well as technique. In his *Salmon* (Fig. 21), as well as in *Bean Curd* and *Shinobazu Pond*, it is clear that he was aiming not only at strict realism but also at an expression of his aesthetic passion.

Yuichi's realism, however, was not based on a normal process of study and practice but was instead gained almost entirely from books, and it therefore lacked a foundation in tradition. Just as Hokusai's prints show a high degree of originality

and concentration but nevertheless a certain stunted quality, so Yuichi's realism, though superior in its degree of concentration, also has a stunted quality. His was a rigid, cramped style that yet conveys an unusual feeling of agony. In this latter sense, Yuichi's art, though limited by the fact that it was acquired from books without the aid of a teacher, seems to fall more easily into the Individualist type than into the Occidentalist type.

THE SCHOOL OF ART IN THE TECHNOLOGICAL COLLEGE

The process whereby modern Japanese art broke through the confines of Yuichi's small world began with the establishment of an official school of art in 1876. The school was a special section of the government college that had been set up under the Ministry of Industry, and one of its stated purposes was to foster the

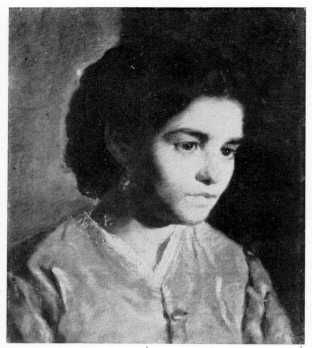

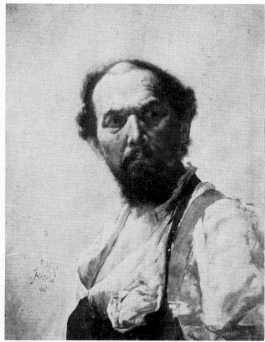

26. *Kawamura Kiyo-o:* Portrait of a Girl. *Oil on canvas;*
height, 28.7 cm.; width, 24.1 cm. About 1870.

27. *Harada Naojiro:* The Shoemaker. *Oil on canvas;*
height, 60.5 cm.; width, 46.5 cm. 1886. Tokyo Uni-
versity of Arts.

introduction of Western techniques into Japanese industry of all kinds. The aim, however, was not purely practical, for another stated purpose was "to study the new realistic styles in order to make up for the short points of traditional art."

Invited from Europe to teach at the new school were the Italian artists Antonio Fontanesi (1818–82; Fig. 23), Vincenzo Ragusa (1841–1928), and Giovanni Cappelletti (died c. 1885). It was particularly fortunate for the future of Western painting in Japan that Fontanesi saw fit to come to the school, for he was not only an excellent technician but also a man of high ideals and excellent character. His own style was in the naturalistic tradition of the nineteenth century, with overtones of the Barbizon-school approach, and this was duly imparted to his students. But what was more important was that Fontanesi represented a living

connection with the painting traditions of Europe. It was no longer necessary for Japanese artists to try to learn from textbooks alone.

Among the artists who came to study under Fontanesi were Koyama Shotaro (1857–1916; Fig. 24), Matsuoka Hisashi (1862–1943); Indo Matate (1861–1914), Nakamaru Seijuro (1841–96), and Takahashi Yuichi's heir, Takahashi Genkichi, all of whom were from Kawakami Togai's private school; Asai Chu (1856–1907) from the school of Kunisawa Shinkuro (1847–77); and Yamamoto Hosui (1850–1906) and Goseda Yoshimatsu (1855–1915; Fig. 22). Fontanesi remained in Japan only until 1878, but, thanks to his training, all the painters named here became prominent figures on the late-nineteenth-century art scene. Together with Kawamura Kiyo-o (1854–1934; Fig. 26) and Harada Naojiro (1863–99; Fig. 27), both of whom

studied painting abroad, they organized, in 1889, the Meiji Art Society, which was the first association of Japanese artists devoted to Western painting.

THE MEIJI ART SOCIETY AND ASAI CHU

By today's standards, the styles displayed by the Meiji Art Society were immature, but they went beyond the copybook efforts of Takahashi Yuichi in that they had a proper foundation and represented a conscious attempt to merge technique with aesthetics. The most advanced painter among the group was Asai Chu, whose works (Figs. 25, 30) show not only a mastery of the lessons taught by Fontanesi but also the first glimmerings of a fresh new Japanese approach to the medium. Asai raised the level of Western painting in Japan to that of a full-fledged art.

Despite Asai's success, however, it would be an exaggeration to say that the art of the Meiji Art Society represented a high level of aesthetic achievement. There were obvious technical developments, but in general one does not feel that these have become a part of the artists' heart and soul. Around 1890 it became fashionable to talk about the Japanization of Western painting, and for a time there was a flood of meretricious works in which traditional Japanese themes were treated in realistic fashion. If anything, these works represented a retreat from the fusion of technique and emotion achieved by Takahashi Yuichi and Asai Chu, and in this sense it could be said that the establishment of Western-style realism as a true art in Japan had to await the appearance of Kuroda Seiki.

KURODA SEIKI AND THE PLEIN-AIR SCHOOL

Kuroda Seiki (1866–1924) went to France in 1884 and studied under Raphael Collin (1850–1917), from whom he acquired a gentle, graceful naturalistic style. The time seems to have been just right for the introduction of this style into Japan.

Having returned to Japan in 1893, the next year Kuroda took over Yamamoto Hosui's private school

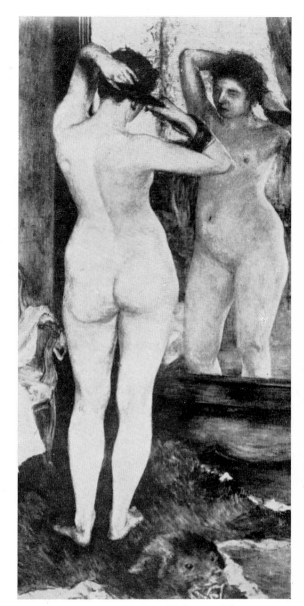

28. *Kuroda Seiki:* Morning Toilette. *Oil on canvas; height, 178.5 cm.; width, 98 cm. 1893. Destroyed by fire in World War II.*

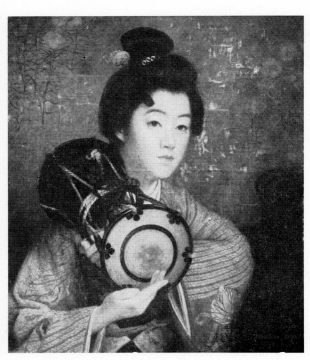

29. *Okada Saburosuke:* Portrait of a Certain Lady. *Oil on canvas; height, 76 cm.; width, 60.5 cm. 1907.*

30. *Asai Chu:* Autumn in Grez *(Grez-sur-Loing). Oil on canvas; height, 80 cm.; width, 60.2 cm. 1901. Tokyo National Museum.* ▷

and renamed it the Tenshin Dojo (Tenshin Academy), a name that has connotations of an artless, natural approach to painting. The school attracted many of the young painters who later formed the mainstream of the government-sponsored exhibitions. There were, first, Fujishima Takeji (1867–1943; Figs. 31, 46–48, 62), Shirataki Ikunosuke (1873–1959), Yuasa Ichiro (1868–1931), and Kita Renzo (1876–1949), who had studied under Yamamoto. There were also Okada Saburosuke (1869–1939; Fig. 29), Nakazawa Hiromitsu (1874–1964), and Yazaki Chiyoji (1872–1947) from the school of Soyama Yukihiko (1859–92); Wada Eisaku (1874–1959; Fig. 43) from the school of Harada Naojiro; Kobayashi Mango (1870–1947) from the school of Ando Nakataro (1861–1912); and Yamamoto Morinosuke (1877–1928) from the Osaka school of Yamanouchi Gusen (1866–1927).

Kuroda displayed his *Morning Toilette* (Fig. 28) at an exhibition by the Meiji Art Society and again at the Fourth National Industrial Fair in Kyoto.

The work, which he had painted in France, won him acclaim as a new leader in Western painting circles, and in 1896, when a department of Western painting was established at the Tokyo Art School, he was appointed director. In the same year he founded the White Horse Society (Hakubakai) as an independent rival to the Meiji Art Society, which he and several of his colleagues felt had become too staid and bureaucratic. In only a few years Kuroda's group, which might be described as the plein-air school, changed the whole Japanese approach to Western art.

Doubtless this was due in part to Kuroda's own talents and the appeal of a new style from Europe. More important, however, was the fact that, with the coming of Kuroda, Western painting ceased to be simply a matter of outward technique and began to acquire a meaning as an expression of the inner spirit. We now begin to find Western-style paintings clearly related to the feelings of the artists.

Kuroda's White Horse Society came to be known

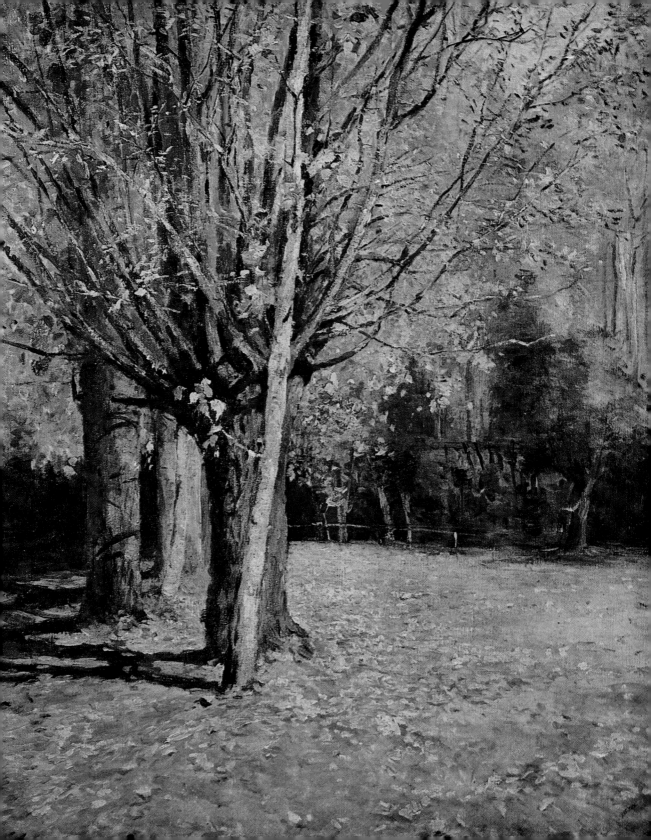

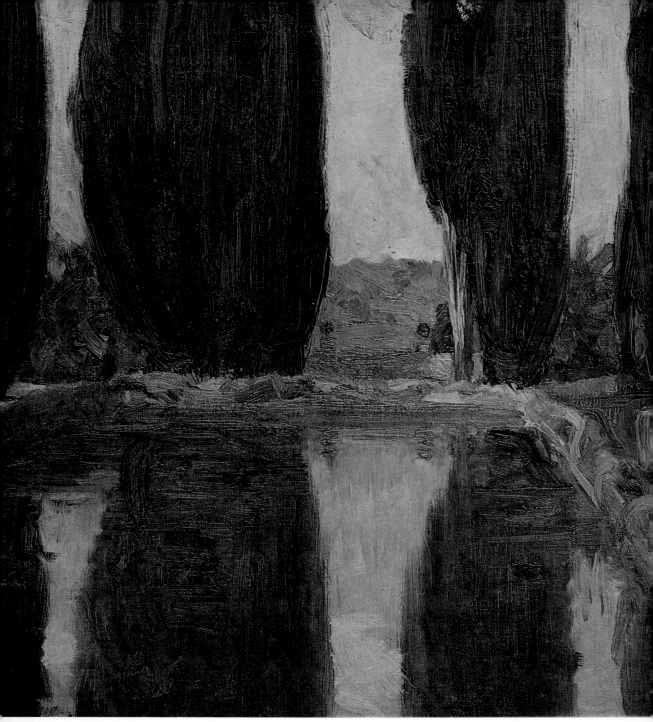

31. Fujishima Takeji: Cypress Trees. *Oil on canvas; height, 35 cm.;*
width, 38 cm. 1908–9. Bridgestone Museum of Art, Tokyo.

32. Kuroda Seiki: Raspberries. *Oil on can-* ▷
vas; height, 45 cm.; width, 33 cm. 1912.

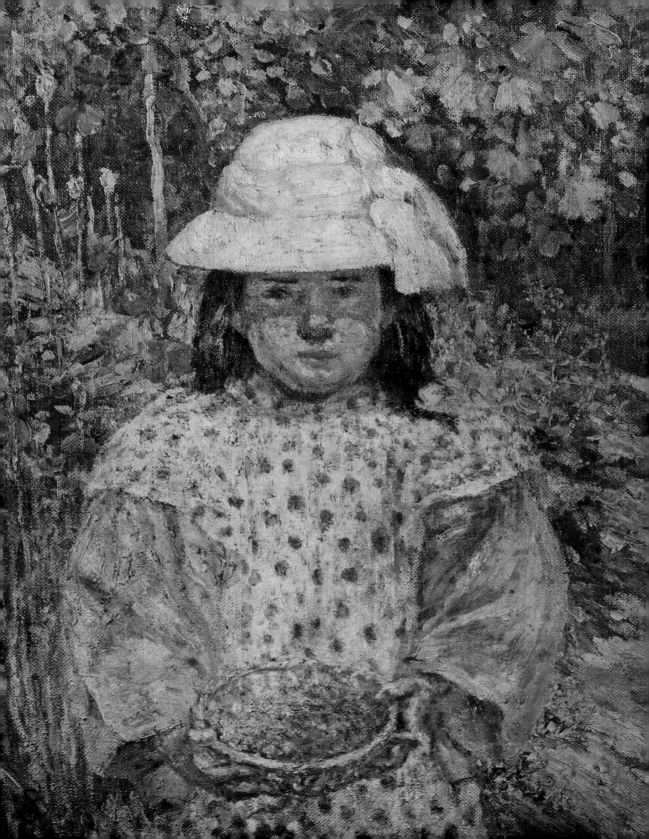

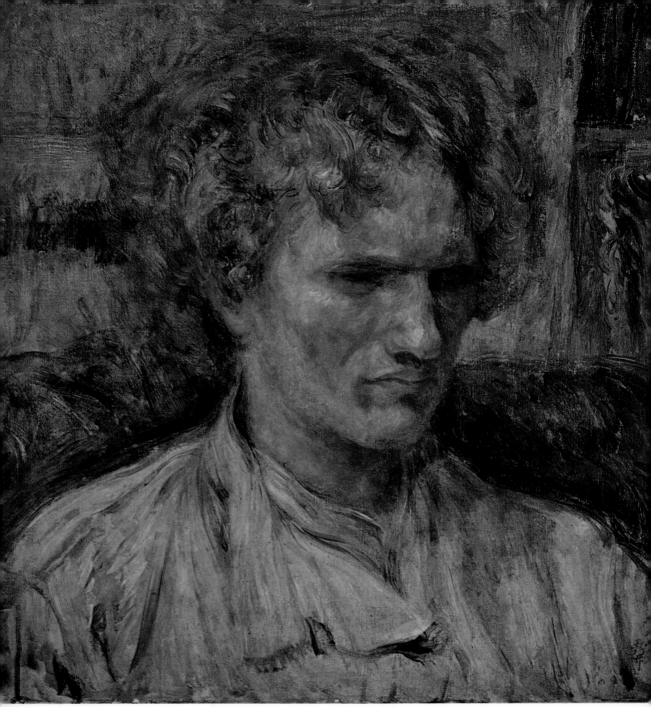

33. Nakamura Tsune: Portrait of Eroshenko. *Oil on canvas; height, 45.5 cm.; width, 42.5 cm. 1920. Tokyo National Museum of Modern Art.*

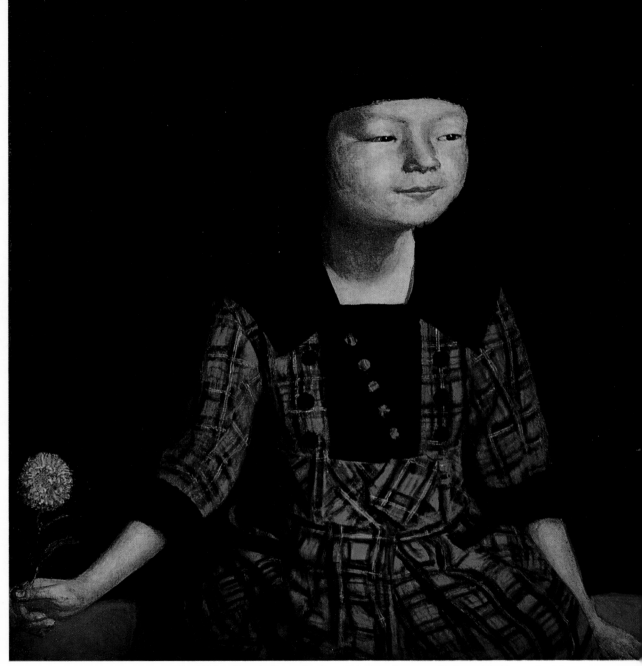

34. *Kishida Ryusei:* Portrait of a Girl *(also known as* Reiko with Flower*). Oil on canvas;
height, 52.5 cm.; width, 45 cm. 1921.*

35 *(overleaf). Sekine Shoji:* The Sadness of Faith. *Oil on canvas;* ▷
*height, 71.5 cm.; width, 99.1 cm. 1918. Ohara Art Museum, Kurashiki,
Okayama Prefecture.*

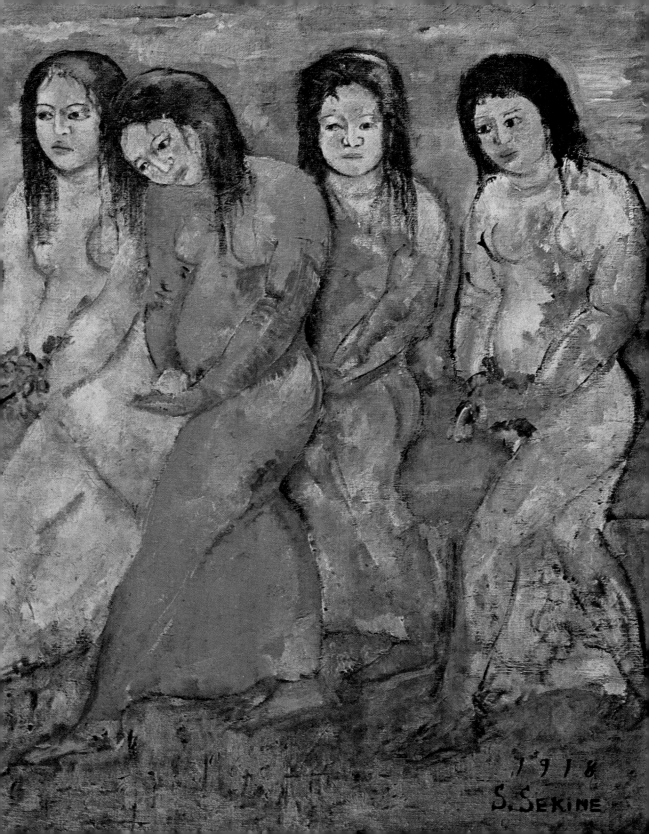

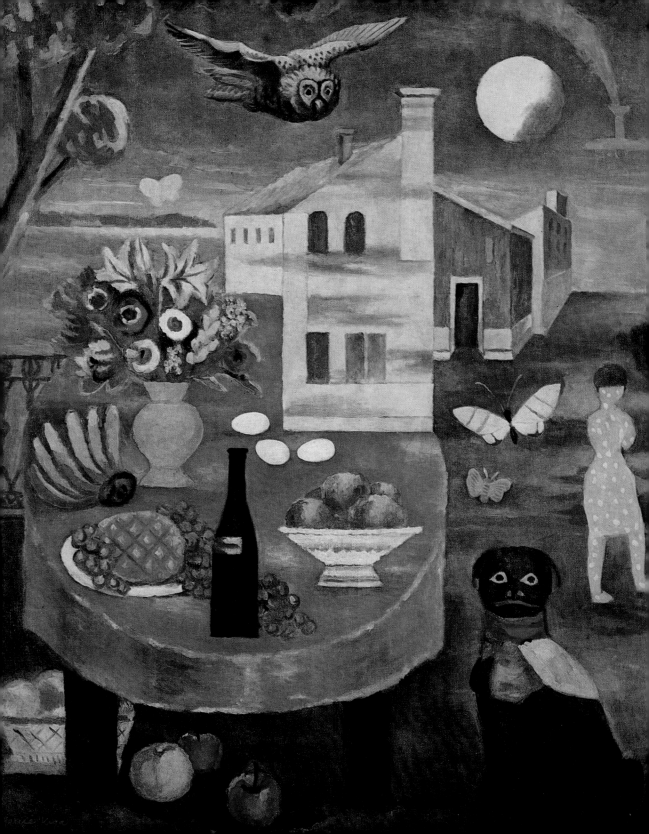

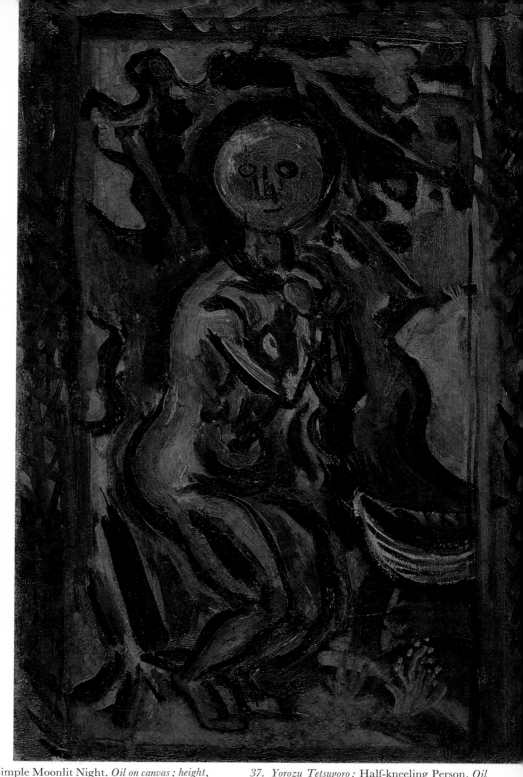

◁ *36. Koga Harue :* A Simple Moonlit Night. *Oil on canvas ; height,*
117 cm. ; width, 91 cm. 1929. Bridgestone Museum of Art, Tokyo.

37. Yorozu Tetsugoro : Half-kneeling Person. *Oil*
on canvas ; height, 39.5 cm. ; width, 27 cm. 1924.

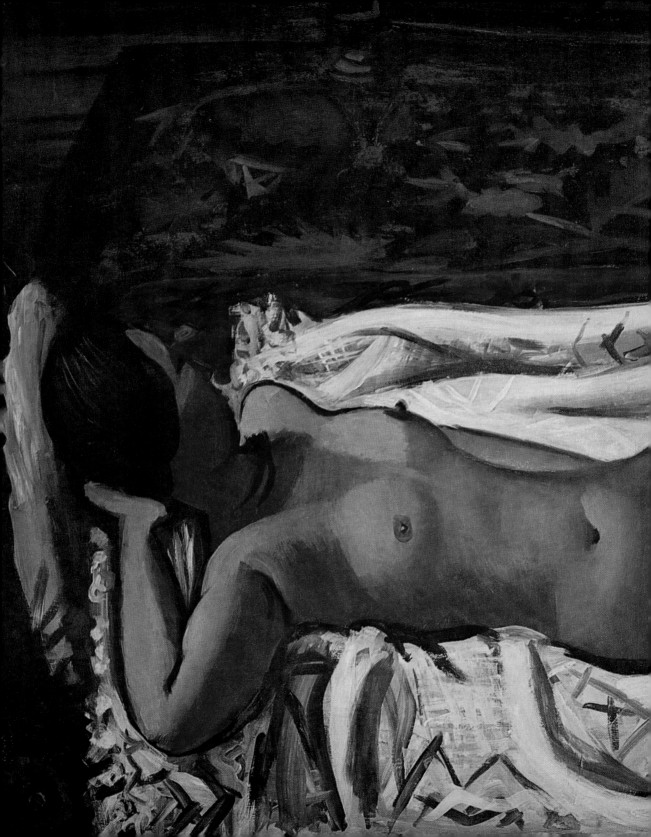

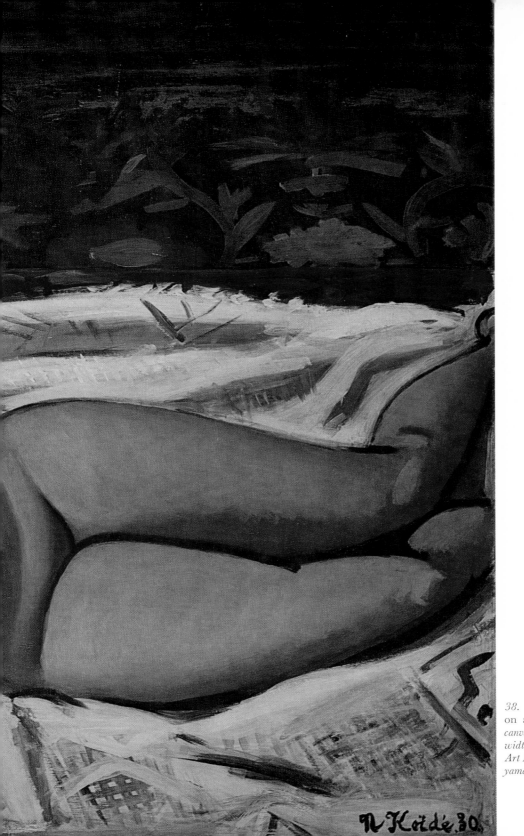

38. *Koide Narashige:* Nude on a Chinese Bed. *Oil on canvas; height, 53 cm.; width, 65.1 cm. 1930. Ohara Art Museum, Kurashiki, Okayama Prefecture.*

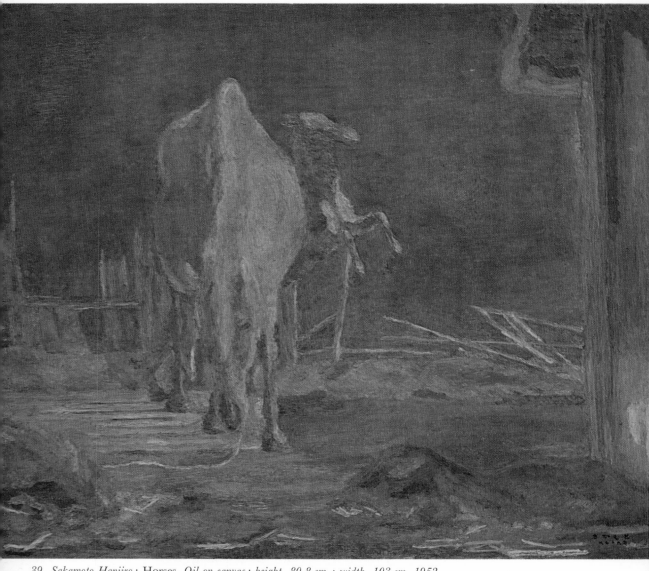

39. Sakamoto Hanjiro: Horses. *Oil on canvas; height, 80.8 cm.; width, 103 cm. 1952.*

40. Yasui Sotaro: Chin Jung. *Oil on canvas; height, 71.2 cm.;* ▷
width, 57.1 cm. 1934. Tokyo National Museum of Modern Art.

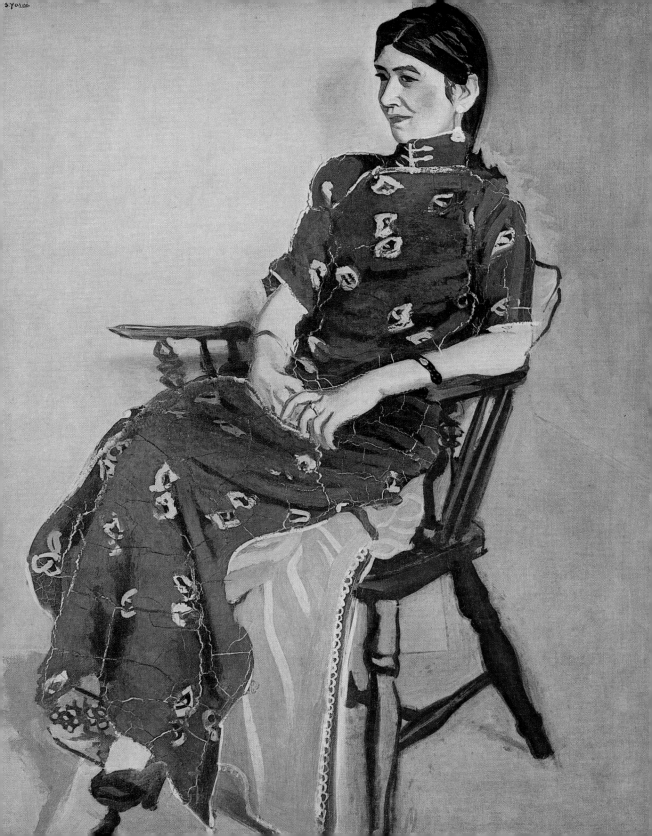

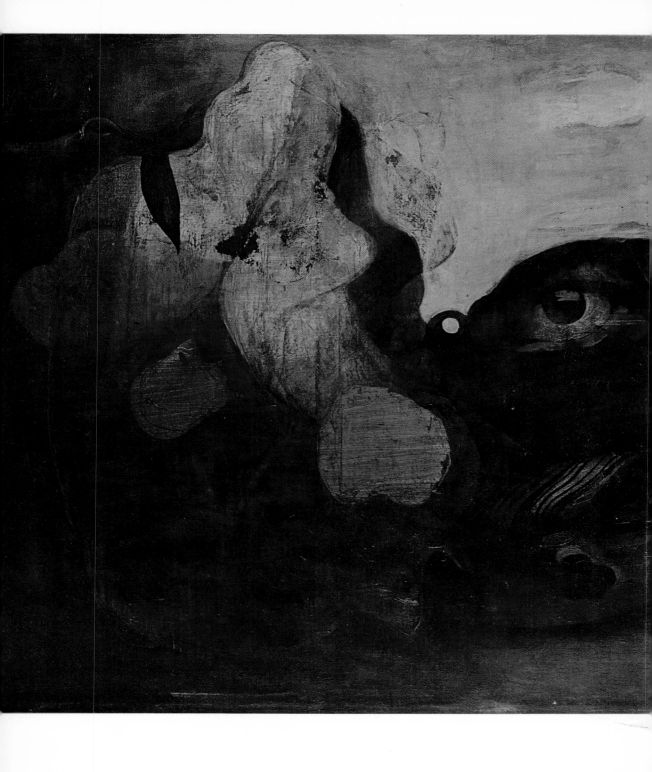

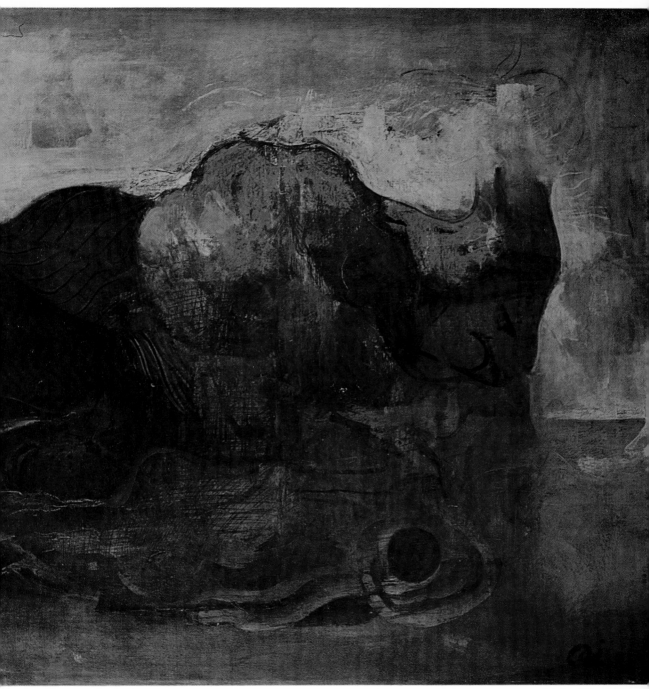

41. Ai Mitsu: Landscape with Eye. *Oil on canvas; height, 101 cm.; width, 192 cm. 1936. Tokyo National Museum of Modern Art.*

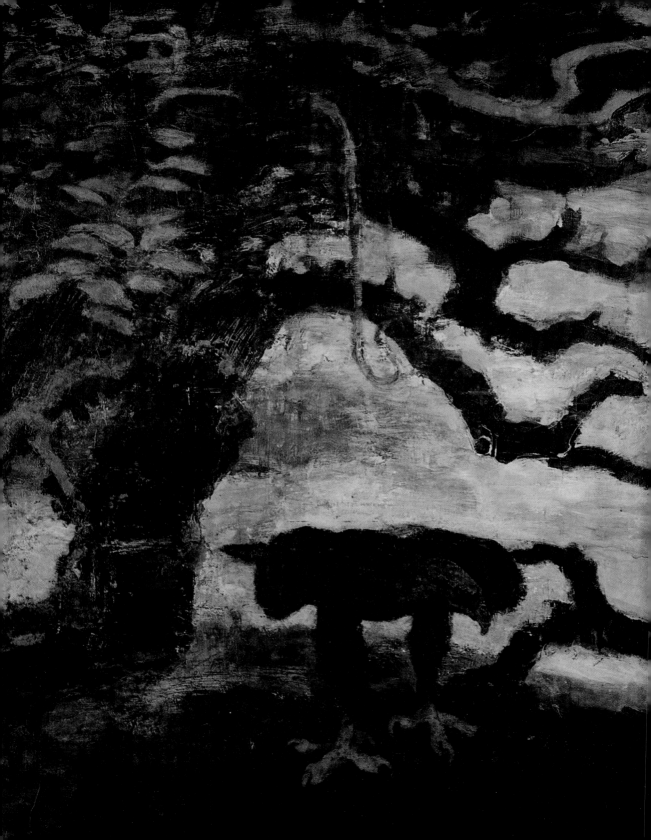

42. *Suda Kunitaro: detail from* Walking Eagle. *Oil on canvas; dimensions of entire painting: height, 128 cm.; width, 160.5 cm. 1940. Tokyo National Museum of Modern Art.*

43. *Wada Eisaku:* Echo. *Oil on canvas; height, 124.8 cm.; width, 91 cm. 1902.*

as the new school. Whereas the earlier painters had demonstrated an academic concern for form and lighting, Kuroda and his followers combined the bright colors of the impressionists with a fresh, informal appreciation of their subjects. The new artists felt free to put their feelings and their moods into their works, with the result that technique became their servant rather than their master.

In contrasting the new approach with the old, Kuroda said: "In painting famous scenery such as that of Miyajima in Aki Province [Hiroshima Prefecture] or Ama no Hashidate [the Bridge of Heaven, in Kyoto Prefecture], the old school strives for a degree of accuracy conforming with the rules they have been taught. The old school approaches a landscape with the idea of recording its exact appearance. The new school, however, tries to paint the feelings inspired by the landscape and to capture the changes that occur when the landscape is enveloped in rain or bathed in bright sunlight. It is

the same with all their paintings, even those showing the coloring and shading of human faces. Normally, a person's cheeks are pink, his lips red, his forehead and the tip of his nose brownish. When an artist of the old school paints a face, he sticks to this coloring and tries to draw exactly what he sees. With the new school it is different. The artist paints what he feels, and it may turn out that the bridge of the nose, which is usually the lightest part of the face, is painted dark, while the tips of the ears are bright red. The results may give the impression that the artist is being whimsical, but it is not really whimsy."

In other words, the artists of the new school felt free to try to give visual expression to the feelings that the subject evoked in them at the moment of painting. Their general adherence to the principles of plein-air painting and impressionism did not bind them to a new set of rules, and they consequently experienced a new freedom of mind and

44. *Kuroda Seiki*: The Storyteller. *Oil on canvas; height, 189 cm.; width, 307 cm. 1898. Destroyed by fire in World War II.*

spirit and felt at liberty to revel in colors without regard for rules concerning the use of lights and darks. Even in painting shadows they were inclined to use purple or blue, thus earning for themselves the name "purple school." They no longer felt bound by the stiff restraints that had characterized the earlier efforts to master foreign painting but were instead free to paint what was inside them.

Kobayashi Mango, one of the earliest members of the Tenshin Dojo, later said: "It is still a delight to look back on it. It is as though a person making his way down a pitch-dark road had suddenly seen a bright ray of light. I do not think I was the only one who had that feeling."

The new painters were the first Japanese to experience the real joy of painting in the Western styles, and it was with them that Western painting in Japan ceased to be a collection of difficult tricks and became a genuine art. This was an appropriate accompaniment to the spirit of social and political freedom that swept through Japan in the latter part of Meiji.

Kuroda himself turned out a number of remarkable works, including *The Storyteller* (Fig. 44), *By the Lake*, and, after the establishment of the annual Ministry of Education Exhibition (Bunten), *Madonna Lilies* and *Raspberries* (Fig. 32). Painting in the Kuroda fashion became the dominant trend not only at the Tokyo Art School and the White Horse Society but at the prestigious government exhibition as well. In effect, Kuroda created the horizon for Western painting in modern Japan, and whether subsequent painters followed his style or rebelled against it, it remained the horizon from which they set forth. The extent of his influence can hardly be exaggerated.

45. Yamawaki Shintoku: Morning at the Railway Station. *Oil on canvas; height, 57 cm.; width, 78.5 cm. 1909. Tokyo University of Arts.*

After Kuroda the starting point for Western painters was emotion rather than the classic mastery of shading, perspective, three-dimensionality, and color values. The European tradition of technical precision was put on the shelf, and there developed a tradition that sprang from the impressionist school, though somewhat out of step with it from the beginning. In effect, Japanese Western-style painting, though more involved with theory than traditional Japanese painting, was less well founded in tradition than was the painting of Europe.

Moreover, the Japanese "impressionist" movement was not a revolt against academicism. Instead, it became a type of academicism in its own right. And before it had developed a really strong backbone, it gave way to the next wave of fashion. Kuroda was followed by Okada Saburosuke, who had also studied under Collin and who also promoted impressionism, but impressionism did not develop in Japan the force that it had had in Europe. It was carried on by such artists as Yamashita Shintaro (1881–1966), Saito Toyosaku (1880–1951), Yamawaki Shintoku (1886–1951; Fig. 45), and Kojima Torajiro (1881–1929), but it would be difficult to say that they went much further than to import new variations in style from Europe.

FUJISHIMA TAKEJI AND AOKI SHIGERU

More original results were realized by Fujishima Takeji and Aoki Shigeru, who, while preserving the principles of the plein-air school of Kuroda, added personal elements of their own.

Fujishima (1867–1943) brought to his Western paintings a knowledge of traditional Japanese painting that led him to a style at once more conceptual

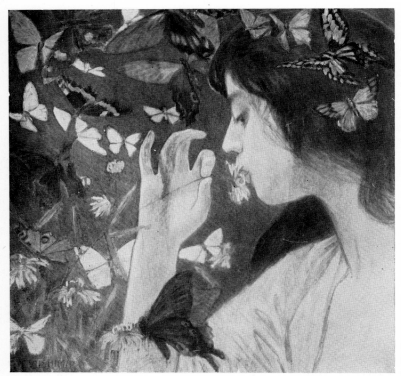

46. *Fujishima Takeji:* Butterflies. *Oil on canvas; height, 43.5 cm.; width, 43.5 cm. 1904.*

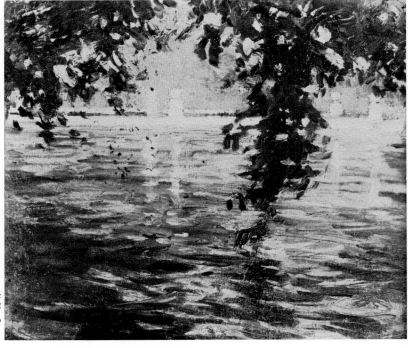

47. *Fujishima Takeji:* Pond at the Villa d'Este. *Oil on canvas; height, 44 cm.; width, 51 cm. 1908–9. Tokyo University of Arts.*

48. *Fujishima Takeji:* The Sky. *Oil on canvas; height, 111 cm.; width, 121 cm. 1912.*

and more decorative than Kuroda's. Having produced such colorful works as *Butterflies* (Fig. 46), he added many decorative paintings to his oeuvre during an extended sojourn in Europe and created a style that was much in vogue in Japan during the second and third decades of the twentieth century. His influence has perhaps had greater strength and scope than that of Kuroda in his later days.

Aoki (1882–1911; Figs. 7, 49–52, 59–61) studied the Kuroda style at the Tokyo Art School, but he added body to it, at the same time achieving a certain uniquely Japanese quality, as in *Seascape* (Fig. 52). Many of his later works contain a literary, romantic element that might well be considered the ultimate expression of the emotionalism and lyricism inherent in the ideas of the Tenshin Dojo.

Aoki was in a very real sense the genius of the Meiji era, and mention of his name brings to mind

such representative works of his as *Harvest of the Sea* (Fig. 7), *The Fish-Scale Palace of the Sea God* (Fig. 51), and *The Tempyo Era* (Fig. 49), all of which have literary themes taken from Japanese history and legend. Besides those just named, many other interesting works by Aoki display the same tendency—for example, *Izanagi Fleeing the Underworld* (Fig. 50), *Jaimini* (founder of the Mimamsa philosophy of India), *Prince Yamato Takeru no Mikoto* (Fig. 61), and *Prince Onamuchi no Mikoto*—and this is the reason why so many people regard him as a literary and historical painter. But just as in the case of Sakamoto Hanjiro, who was Aoki's intimate friend from boyhood on, Aoki's ability was best displayed in realistic treatments of natural scenes. In fact, there are some who consider it a matter of great regret that he made his digression to literary themes before he had a chance to exhibit his realism to the

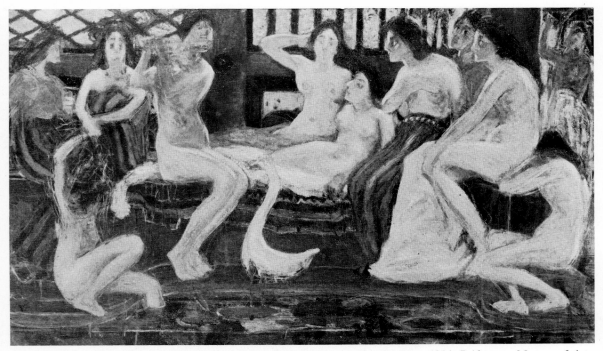

49. *Aoki Shigeru:* The Tempyo Era. *Oil on canvas; height, 46 cm.; width, 76.5 cm. 1904. Bridgestone Museum of Art, Tokyo.*

full. As it is, his works include such marvelously realistic efforts as his pencil sketches of the Myogi volcanoes in Gumma Prefecture and his seascapes depicting the Mera shore of Chiba Prefecture. In *Seascape* (Fig. 52) we are led somehow to feel that we are being absorbed into the intense movement and rhythm of the surging waves. The breakers roll and rumble with such force that they threaten to break out of the confines of the picture. Such effects attest to Aoki's essential oneness with nature.

THE SECRET WHIS-
PERING OF NATURE
A passage in one of Aoki's letters—a description of rain—was highly praised by the haiku poet Kawahigashi Hekigodo as an unusually fine piece of writing: "The rain these days has a loneliness about it. It moves me so that I never tire of looking at it and listening to its sound. It patters on the young leaves of the trees and the banana plants, and from the leaves it drips into pools of water below. The same thing happens in the garden next door and across the street. Everything is green wherever I look, and it all echoes the sound of the rain. The young leaves flourish, and every plant humbly receives the joyful nectar, its head bent and hands clasped, unshaken by wind. Listen! Is a titmouse chirping somewhere? Look at the persimmon and the tangerine trees next door! Each time the weight of rain tilts a leaf, a drop of water falls from its tip, reflecting the intermittent sunlight. And when the tiny spheres of water fall off as the leaves here and there make minute movements, yellow-tinged diseased and dried-up leaves that have been lingering on the branches flutter down in spirals, even though there is not the slightest wind.

"A large pool of water has formed at the place next door, whose yard is separated from mine by a

50. *Aoki Shigeru:* Izanagi Fleeing the Under-world. *Water colors; height, 48 cm.; width, 33.3 cm. 1903. Tokyo University of Arts.*

51. *Aoki Shigeru:* The Fish-Scale Palace of the Sea God. *Oil on canvas; height, 181.5 cm.; width, 70 cm. 1907. Bridgestone Museum of Art, Tokyo.*

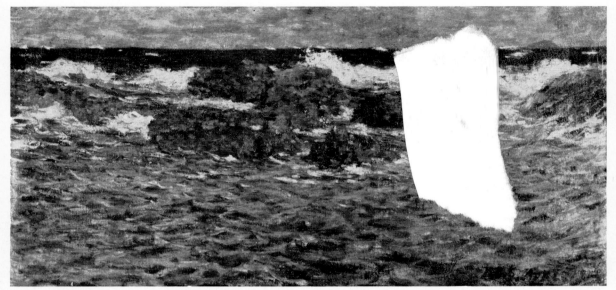

52. *Aoki Shigeru:* Seascape. *Oil on canvas; height, 35 cm.; width, 71.5 cm. 1904. Bridgestone Museum of Art, Tokyo.*

fence. I guess the ground there is lower than mine, for the water flows from here to the nextdoor lot. A rivulet of water runs between the supports of an abandoned wooden clog. And the rain goes on, pouring there, pattering here; in a shower there, in sheets here; splashing there, flowing here."

Aoki, though observing nature, seems himself to have become a part of the scene, now as dead leaves fluttering in the air, now as water running between the supports of a wooden clog, now as a bird chirping secretly. To the passage just quoted, he adds the following impression: "Mysterious and profound—this must be the murmuring of nature the limitless. Secret and abstruse—it must be foretelling the fate of all beings."

Can we not say then that it was this deep sensitivity that enabled Aoki to listen to the murmurs of limitless nature? In other words, is it not because he was able to hear the secret words of nature that he produced realistic paintings filled with life and mystery? If this is true, then we can see a natural connection between his literary and historical paintings and his realistic works, for, once life and mystery

had been brought into historical contexts, he was unfettered in displaying his unique sensitivity. In fact, *Izanagi Fleeing the Underworld* and *Prince Yamato Takeru no Mikoto* are good examples in whose human figures, backgrounds, and colors Aoki's perceived world of mysteries is vividly realized.

ROMANTIC MOOD AND HISTORICAL PAINTING During the Meiji era it became popular to employ themes from Japanese history in both Western-style painting and *nihonga*—that is, Japanese painting as distinguished from Western-style painting. (*Nihonga*, it should be noted, is a term that came into use during the Meiji era to make this distinction.) Among the *nihonga* artists it was primarily the *yamato-e* schools that took this course. At first it was little more than certain contrivances in expression, using the same themes as before, but from the middle years of Meiji on, historical events were approached from new angles, and innovations were made in interpreting them. During the early 1900s, shortly after the Japan Art Academy was founded, a number of young painters,

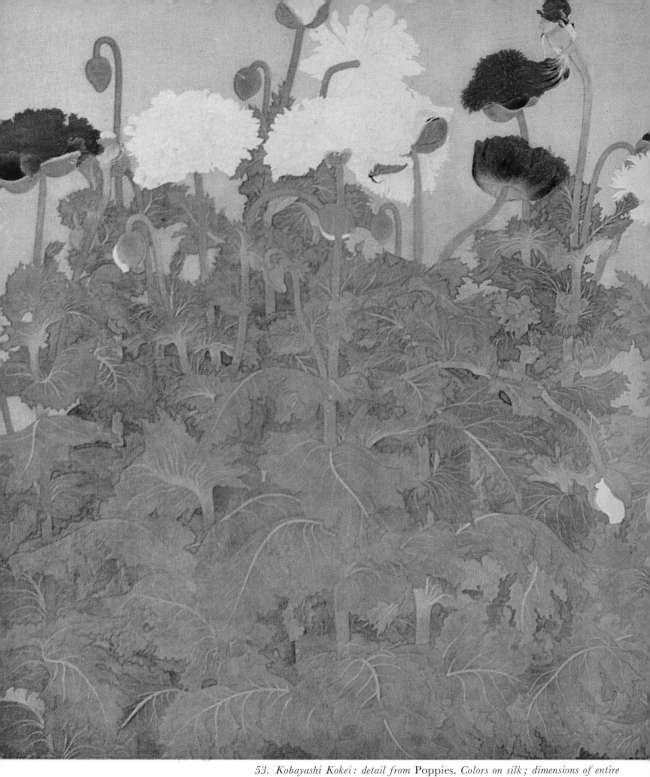

53. Kobayashi Kokei: detail from Poppies. *Colors on silk; dimensions of entire painting: height, 165 cm.; width, 97.6 cm. 1921. Eisei Bunko, Tokyo.*

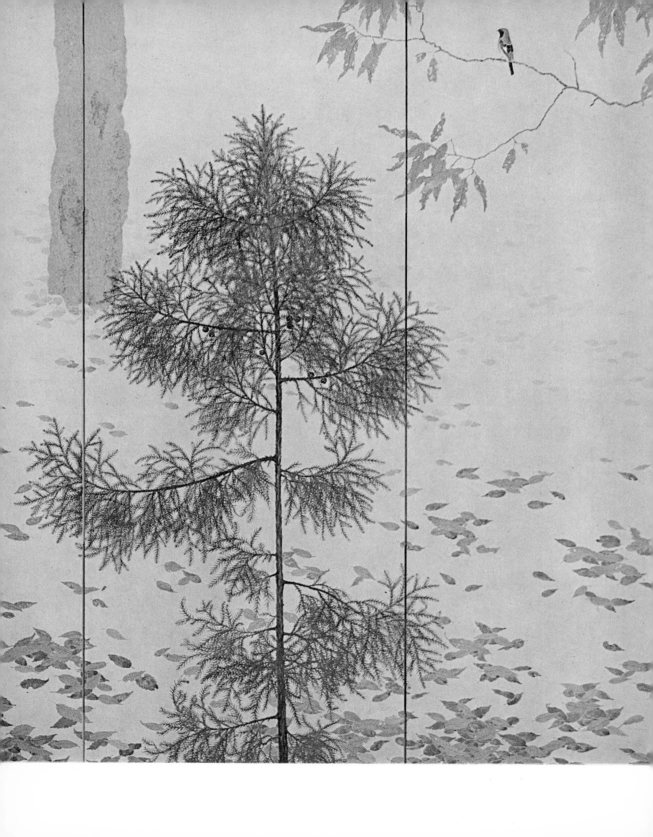

54. Hishida Shunso: detail from right-hand screen of a pair of sixfold screens entitled Fallen Leaves. *Colors on paper; dimensions of each screen: height, 156 cm.; width, 365 cm. 1909. Eisei Bunko, Tokyo.*

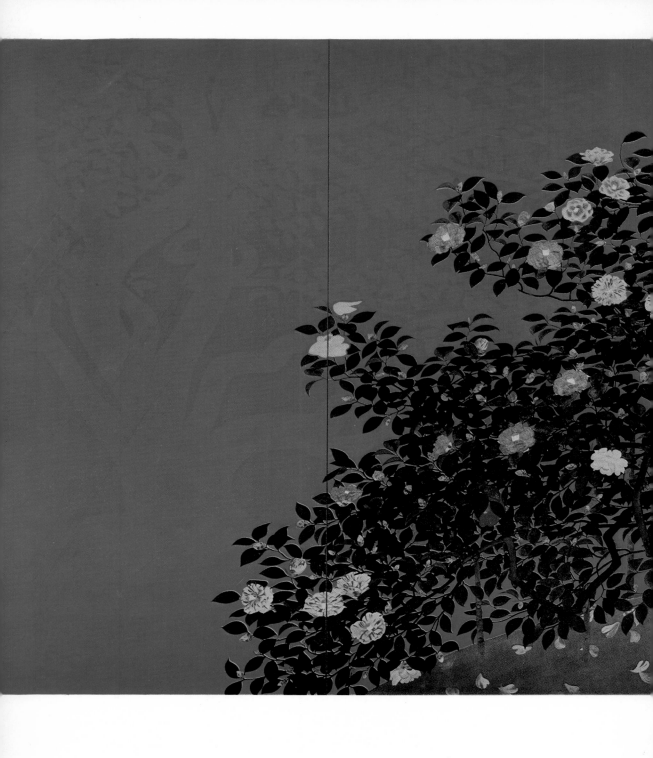

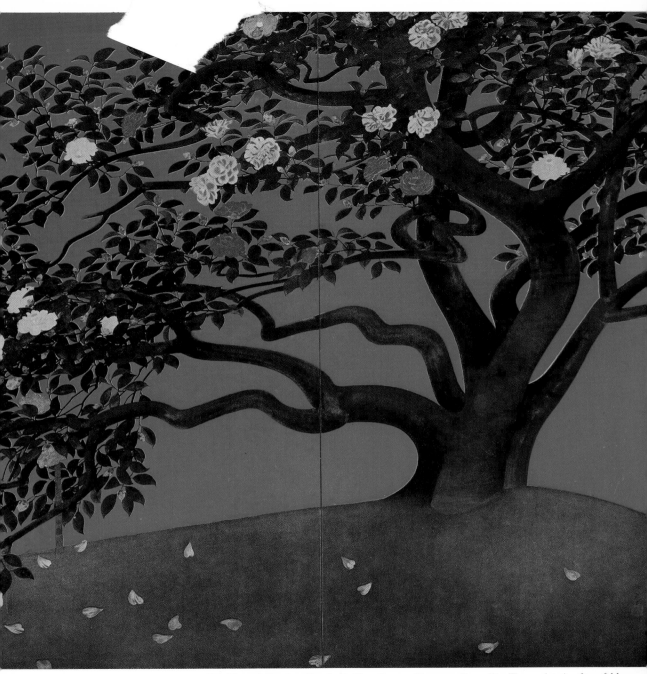

55. Hayami Gyoshu: Petals Falling from a Famous Camellia Tree. *A pair of twofold screens; colors on paper; dimensions of each screen: height, 167 cm.; width, 169 cm. 1929.*

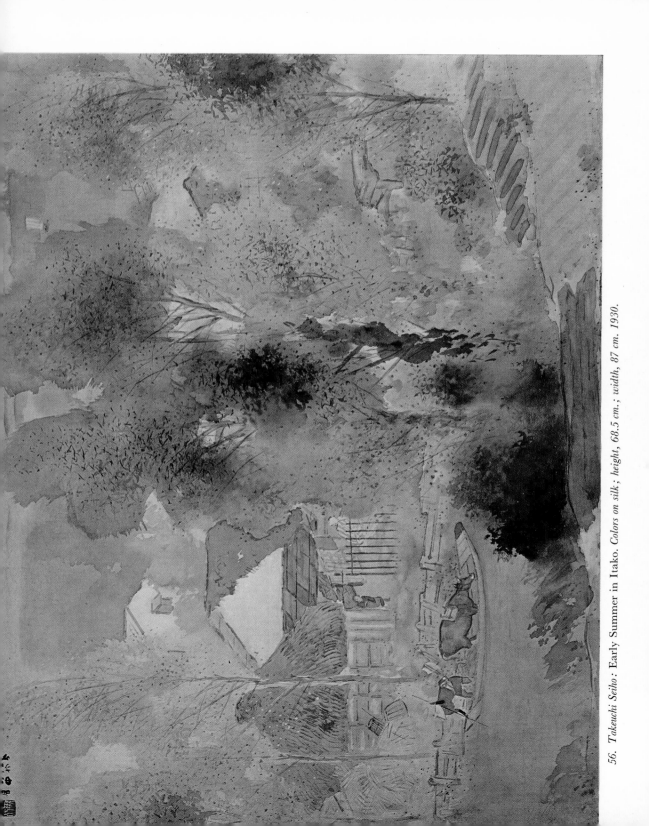

56. *Takeuchi Seihō: Early Summer in Itako. Colors on silk; height, 68.5 cm.; width, 87 cm. 1930.*

57. *Murakami Kagaku: Mountains in Summer. Colors on paper; height, 28.7 cm.; width, 42.8 cm. 1931.*

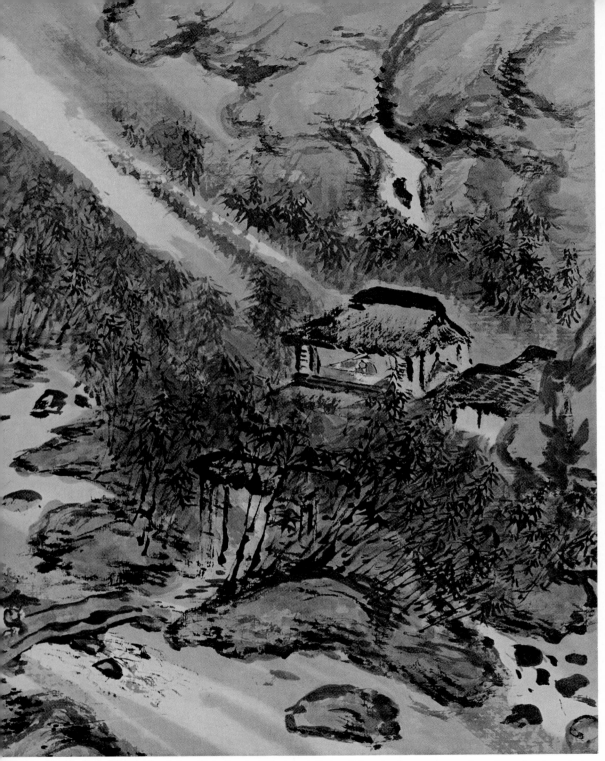

58. *Tomioka Tessai: detail from* Reading in Wind and Rain. *Ink and colors on paper; dimensions of entire painting: height, 125 cm.; width, 60.5 cm. 1912.*

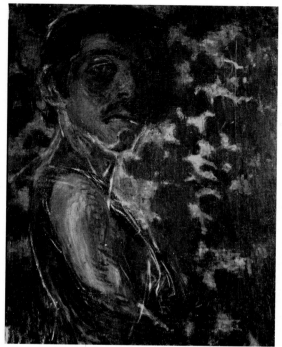

59. *Aoki Shigeru:* Self-Portrait. *Oil on canvas; height, 81 cm.; width, 60.5 cm. 1903.*

60. *Aoki Shigeru:* A Woman's Face. *Oil on canvas; height, 45.5 cm.; width, 33.4 cm. 1904.*

including Shimomura Kanzan, Yokoyama Taikan, and Hishida Shunso, undertook large-scale historical paintings embodying new ideas and thereby giving rise to extended debates on the nature of historical painting. On the whole, imaginatively conceived historical paintings were welcomed with interest by the romantic sentiment of the times.

In Western-style painting circles as well, after around 1890, the Japanization of Western-style painting was advocated, and it became a favored practice to depict historical themes with Western realism. This was an attempt to exhibit the superiority of oil painting over *nihonga* when it came to out-and-out realism.

The efforts of both the *nihonga* painters and the Western-style painters were accompanied by their own difficulties. In the Western-style treatment of historical themes there were no emotional ties with the stories depicted, and there were no necessary connections between theme and technique. Such paintings showed only how realistic the painting could look if done in oils. In the new historical paintings of the Japan Art Academy, although it is true that some like Taikan's *Ch'u Yuan* were of superior quality, most artists were more concerned with concepts than with techniques. That the latter were quite immature and still in the experimental stage is evidenced by the rapid appearance and disappearance of such new styles as the suppressed-line style.

THE RELATIONSHIP AMONG FUJISHIMA, AOKI, AND TAKEHISA In view of the developments in the Japanese art world during the early 1900s, such works as Fujishima Takeji's *Memory of the Tempyo Era* may

61. *Aoki Shigeru:* Prince Yamato
Takeru no Mikoto. *Oil on canvas;
height, 70 cm.; width, 37 cm. 1906.*

be regarded as early attempts by the Western-style group to respond to the tide of romantic historical paintings. Fujishima was searching for a new angle from which to view the connection between the content and the form of historical paintings. Aoki took up this idea and developed it in vivid fashion. His series of sketches on mythical narratives, including *Izanagi Fleeing the Underworld,* was submitted in the White Horse Society competition of 1903, and he was presented with the first White Horse award—quite an unusual achievement for a student—perhaps because his theme so exactly suited the artistic mood of the age.

For Aoki, nature was a "mysterious and profound" secret. Nature was identical with poetry to him, and when there was poetic sentiment, the vitality of nature made its appearance. The mythological underworld, the events in the *Kojiki* (Record of Ancient Matters), the world of the Tempyo court and of Man'yo poetry—all these were sensed and expressed in luxurious color and vivid form, with radiance and with rhythm. In Aoki's painting, theme and technique were products of the same concept. Perhaps it would be most accurate to consider his historical works as lyric, romantic paintings. The symbolist poet Kambara Ariake (1876–1952) described Aoki as a "bewitching painter," no doubt because of the intense mysticism and romanticism that characterize the greater part of his work.

Aoki is exceptional among modern Japanese painters. Fujishima Takeji, who was his senior and had inspired him, was more typical. Takehisa Yumeji, who was known for his book illustrations of sorrowful scenes, was deeply impressed by Aoki's *Fish-Scale Palace of the Sea God,* but he was more of a poet than a painter. It is worth noting that Takehisa chose his art name Yumeji (incorporating the character *ji* from Fujishima's art name Takeji) because he so greatly admired Fujishima. The relationship among the three artists was an interesting one. Although they differed from one another, the three of them together formed a special link in the history of modern Japanese art and, at the same time, provided inspiration for many artists of the following generation.

62. *Fujishima Takeji: Fang Hui. Oil on canvas; height, 64 cm.; width, 52 cm. 1926.*

WHETHER JAPANESE "impressionism" closely resembled French impressionism or not, it was undoubtedly a form of art that developed under the influence of French impressionism. It could be argued that the work of its first exponent, Kuroda Seiki, was best carried on not by his many imitators in the Ministry of Education exhibits but by the deviationists Fujishima and Aoki, one of whom veered toward decorativeness and the other of whom veered toward romanticism.

If we go back to the types inherited from the Edo period, Kuroda can be classed among the Occidentalists, Aoki among the Individualists with an Occidentalist bent, and Fujishima as an Occidentalist and Reformist who eventually became an Individualist.

CHAPTER THREE

The Tenshin Group
and Its Influence

OKAKURA TENSHIN AND THE NEW JAPANESE-STYLE PAINTING Modern Japanese painting is by no means confined to styles adopted from the West. On the contrary, many interesting developments have occurred in the field of the traditional Japanese style as well. Indeed, if this had not been the case, the history of modern Japanese art, though easier to trace, would probably have been a barren matter at best: little more than a recitation of how a foreign art was imported and mastered.

In this sense, the work of Okakura Tenshin (also known as Okakura Kakuzo; 1862–1913) is of great significance, for it was Okakura more than anyone else who led the Meiji revival of traditional styles. A critic rather than an artist, Okakura was the first principal of the Tokyo Art School, which was opened in 1889, and later the founder of the Japan Art Academy (Nihon Bijutsuin), as well as one of the early leaders of the Oriental division at the Boston Museum of Fine Arts. In Meiji Japan, where Occidental art and Oriental art came into dramatic conflict, Okakura plotted the course of a proud new Asian art of the future, and his writings in English on the spirit of the Orient are widely read in the West even today. The conditions surrounding the development of a new Japanese style have been outlined by Okakura himself in his book *The Ideals of the East* (New York: Dutton, 1904; reprinted: Rutland and Tokyo: Tuttle, 1970):

". . . The first reconstructive movement of the Meiji period was the preservation and imitation of the ancient masters, led by the Bijitsu [sic] Kyo-Kai Art Association. This society, made up of the aristocracy and connoisseurs, opened annual exhibitions of old *chefs-d'oeuvre* and conducted competitive salons in a spirit of conservatism which naturally drops by degrees into formalism and meaningless reiteration. On the other hand, that study of Western realistic art which had slowly gained ground under the late Tokugawa, a study in which the attempts of Shibakokan [sic] and Ayodo [Aodo Denzen] are conspicuous, now found an opportunity for unrestricted growth. That eagerness and profound admiration for Western knowledge which confounded beauty with science, and culture with industry, did not hesitate to welcome the meanest chromos as specimens of great art ideals.

"The art which reached us was European at its lowest ebb—before the *fin-de-siècle* aestheticism had redeemed its atrocities, before Delacroix had uplifted the veil of hardened academic *chiaroscuro*, before Millet and the Barbizons brought their message of light and colour, before Ruskin had interpreted

63. *Yokoyama Taikan: detail from a hand scroll entitled* The Wheel of Life. *Ink on silk; dimensions of entire scroll: height, 55 cm.; length, 38.64 m. 1923. Tokyo National Museum of Modern Art.*

the purity of pre-Raphaelite nobleness. Thus the Japanese attempt at Western imitation which was inaugurated in the Government School of Art—where Italian teachers were appointed to teach—grovelled in darkness from its infancy, and yet succeeded, even at its inception, in imposing that hard crust of mannerism which impedes its progress to the present day. But the active individualism of Meiji, teeming with life in other cycles of thought, could not be content to move in those fixed grooves which orthodox conservatism or radical Europeanisation imposed on art. When the first decade of the era was passed, and recovery from the effects of civil war was more or less complete, a band of earnest workers strove to found a third belt of art-expression, which, by a higher realisation of the possibilities of ancient Japanese art, and aiming at a love and knowledge of the most sympa-

thetic movements in Western art-creations, tried to reconstruct the national art on a new basis, whose keynote should be 'Life true to Self.' This movement resulted in the establishment of a Government Art School at Ueno, Tokyo, and, since the disintegration of the faculty in 1897, is represented by the Nippon Bijitsuin [*sic*] at Yanaka, in the suburbs of the city, whose biennial exhibitions reveal, it is hoped, the vital element in the contemporary art activity of the country.''

This is an excellent summary of developments that were taking place. The good reception accorded to Japanese handicrafts at the Vienna exposition of 1873 sparked a revival of traditional arts, and as early as 1879 a group called the Ryuchikai (Dragon Pond Society) began to champion the preservation of traditional arts. With this group as a nucleus, government support was gained for

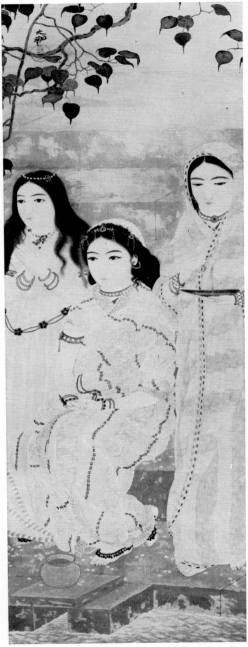

64. *Yokoyama Taikan:* Floating Lamps. *Colors on silk; height, 147 cm.; width, 51.3 cm. 1909.*

exhibitions of works by Edo-period artists and their successors, and after 1887, when the Ryuchikai became the Nihon Bijutsu Kyokai (Japan Art Association), of which Okakura speaks, the organization in turn became the recognized citadel of conservatism. It was between this group of strict traditionalists and the all-out advocates of European art that Okakura sought to establish a middle ground or, as he put it, a "third belt."

THE JAPAN ART ACADEMY

An American named Ernest Fenollosa (1853–1908), who came to Japan as a university teacher in 1878, worked with Okakura Tenshin to promote interest in pre-Edo Japanese art, and the rediscovery of the earlier periods contributed much to the formation of the "third belt," which became manifest in 1898 as the Japan Art Academy. In accordance with Okakura's precepts, the artists of this new school sought not only to explore the possibilities of Japanese art more deeply but also to incorporate what was most "sympathetic" from Western art. Their purpose was to create a new Japanese art suited to their own spirits and their own times. Of the academy, Okakura wrote, again in *The Ideals of the East:*

"According to this school, freedom is the greatest privilege of an artist, but freedom always in the sense of evolutional self-development. Art is neither the ideal nor the real. Imitation, whether of nature, of the old masters, or above all of self, is suicidal to the realisation of individuality, which rejoices always to play an original part, be it of tragedy or comedy, in the grand drama of life, of man, and of nature."

Okakura herein signals the birth, in the Japanese world of art, of the spirit of youth and freedom that characterized the Meiji era. The artists of the academy felt that both conservative traditionalism and Europeanization hampered their freedom and that they would discover true creativity only along the "third belt." In terms of the types mentioned in Chapter One, they thought they could find true independence only by transcending the Occidentalist and Reformist types.

This was easier said than done, and the academy

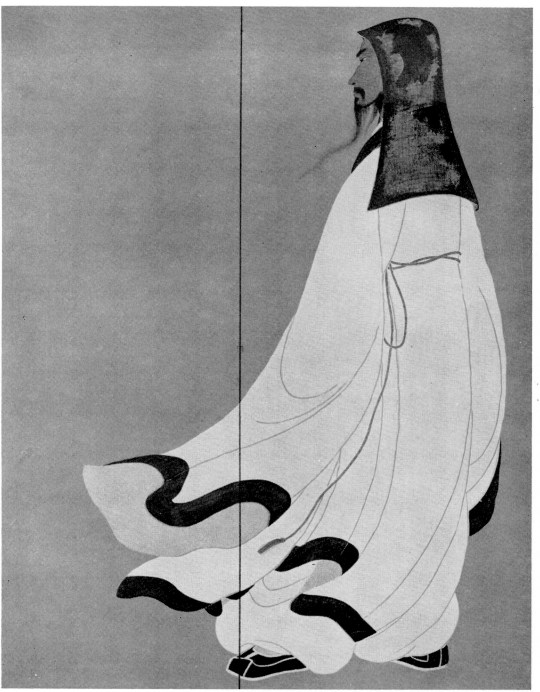

65. *Yokoyama Taikan: detail from left-hand screen of a pair of sixfold screens entitled* Master Five Willows *(T'ao Yuan-ming). Colors on paper; dimensions of each screen: height, 169.4 cm.; width, 361.2 cm. 1912. Tokyo National Museum.*

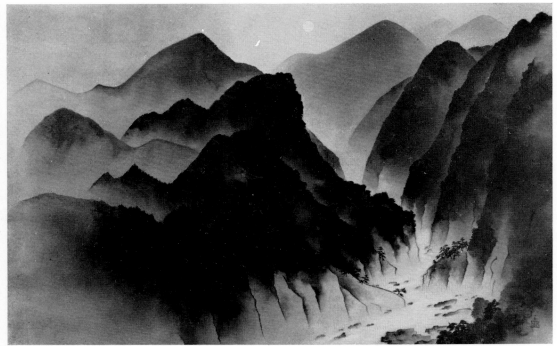

66. *Yokoyama Taikan:* The Sound of a Mountain River. *Colors on paper; height, 76.2 cm.; width, 115.2 cm.*
1939.

artists were destined to struggle for many years in quest of their romantic ideal of freedom. As to their concrete methods, one of the most important was the study of early Japanese art. As a result of social changes that were in progress at the time, more and more examples of pre-Edo art were being discovered in old shrines and temples, as well as in the collections of noblemen and daimyo. The scope and the variety of traditional art were coming into view as they had never done in the Edo-oriented days of the Nihon Bijutsu Kyokai. During this period, artists were first learning about and seeing many of the classic works now known to every schoolchild, and the experience was a shattering revelation.

Simultaneously, after Kuroda Seiki, Japanese Western-style painting was casting off the bonds of mannerism and, in the works of such men as Fujishima Takeji and Aoki Shigeru, acquiring a new freedom that was at once in tune with the Meiji spirit and in closer affinity with the aims of the academy artists. By about 1900 these latter had reacted to the dual stimulus of the traditional and the European to the extent that they were beginning to grasp the "third belt."

KANZAN, TAIKAN, AND SHUNSO Representative of the first wave of academy artists were Shimomura Kanzan (1878–1930), Yokoyama Taikan (1868–1958), and Hishida Shunso (1874–1911), all of whom were direct disciples of Okakura Tenshin. These three artists were all alike in that their point of departure was the classic Kano style as represented in the works of Kano Hogai (1828–88; Fig. 67) and Hashimoto Gaho (1835–1908), and this link with

tradition was an undercurrent in their later development. They were also influenced on the one hand by early Buddhist paintings, classic scroll paintings, and the ink paintings of Sesshu and on the other hand by principles of light and space revealed in Western painting.

Of the three, Kanzan (Figs. 68, 69) devoted the greatest effort to studying the works of the Heian (794–1185) and Kamakura (1185–1336) periods and to reviving techniques not known to the artists championed by the Nihon Bijutsu Kyokai. Kanzan made skillful use of these techniques in creating a series of imposing paintings of historical subjects, including *The Empress Komyo, The Cremation,* and *The Dew at Ohara.* These were ambitious paintings on subjects not yet handled by modern Japanese artists, and they were done with sufficient skill to gain Kanzan a considerable reputation. Today they look somewhat primitive, but they undoubtedly set the course for one branch of the new Japanese school: a course that might from the technical viewpoint be described as neoclassical. In the Ministry of Education exhibitions, Kanzan distinguished himself with such works as *Autumn in the Forest* (Fig. 68) and *Devils,* and after the academy was reconstituted in 1914, he displayed *The Stumbling Priest, Gray Fox,* and other works that attracted much attention. Kanzan's new style, a variation derived from the Buddhist paintings and *yamato-e* of the Heian period, had a great influence on artists of the next generation.

By way of contrast, Taikan (Figs. 8, 63–66) and Shunso (Figs. 54, 73) experimented with a type of suppressed-line painting that for a time gained them a reputation as the destroyers of the traditional Japanese style. Critics in the press used such terms as the "vague style," the "hazy style," or even the "changeling style" in describing their works, because their treatment of space and light depended more on color than on the line that was so characteristic of traditional painting. "Changeling" was meant to suggest that one could not tell whether Taikan and Shunso were painting Japanese pictures or Western pictures.

Taikan and Shunso studied classical painting just as Kanzan had done, but instead of adopting its

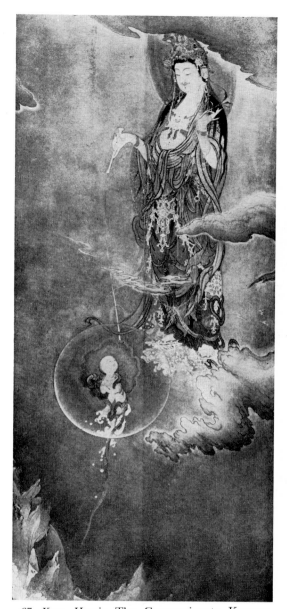

67. *Kano Hogai:* The Compassionate Kannon. *Colors on silk; height, 196 cm.; width, 83 cm. 1888. Tokyo University of Arts.*

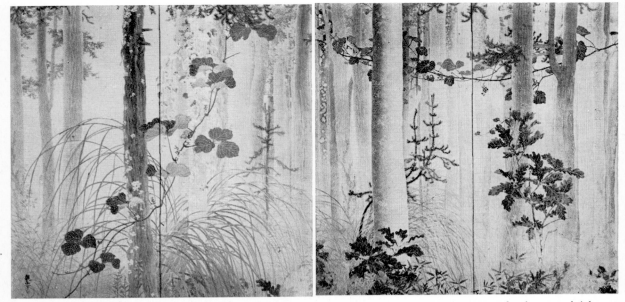

68. Shimomura Kanzan: Autumn in the Forest. *A pair of twofold screens; colors on paper; dimensions of each screen: height, 170 cm.; width, 170 cm. 1907. Tokyo National Museum of Modern Art.*

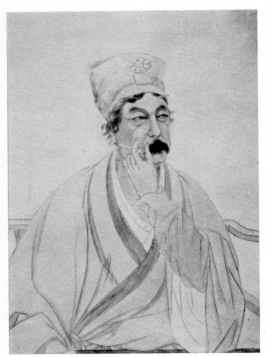

69. Shimomura Kanzan: detail from a sketch for Master Okakura Tenshin. *Colors on paper; dimensions of entire sketch: height, 137 cm.; width, 67 cm. 1922. Tokyo University of Arts.*

70. *Tsuchida Bakusen: right-hand screen of a pair of twofold screens entitled* Bathhouse Girls. *Colors on silk; dimensions of each screen: height, 227 cm.; width, 215 cm. 1918.*

techniques they aimed at capturing its spiritual qualities and its mood and at expressing these intangible elements in a new way. Though their flirtation with Western painting was mild and of a technical nature, it nevertheless gained them a reputation among traditionalists as iconoclasts, and the failure of their paintings to appeal to the general art lover lost the academy as a whole much of its popularity. After a time, however, the two succeeded in winning recognition for a genuinely new and fresh Japanese style.

Shunso's *Fallen Leaves* (Fig. 54) and *Black Cat* (Fig. 73) tend toward naturalism, while Taikan's *Mountain Path, Floating Lamps* (Fig. 64), and *Eight Views of the Hsiao and the Hsiang* are of a more idealistic bent, but each artist achieved brilliant results, and their effect on later painters working

in the Japanese style was great. Their work may be regarded as the culmination of the movement begun by Okakura Tenshin, for here was a new Japanese style of painting, and its scope was further broadened by the long-lived Taikan, who went on in the succeeding decades to turn out such works as *The Wheel of Life* (Fig. 63) and *Cherry Blossoms at Night* (Fig. 8).

TAIKAN AND THE NEW NIHONGA

Opinions may be divided as to who was the most representative *nihonga* artist of the modern period. Of course Tomioka Tessai would be among the most likely candidates, and Hishida Shunso is an unforgettably important artist. Some might name Kobayashi Kokei or Hayami Gyoshu or an artist of the Kyoto school like Takeuchi Seiho,

71. *Hayami Gyoshu:* Tree. *Colors on silk; height, 162 cm.; width, 68.5 cm. 1925.*

Tsuchida Bakusen, or Murakami Kagaku. To the minds of others might come the names of Kawai Gyokudo and Hirafuku Hyakusui. But as far as the meaning of *nihonga* in modern Japan goes, no artist equals Taikan in significance as having been its strong proponent, for we can easily suppose that if it had not been for Okakura Tenshin, the mainstream of *nihonga* in the Meiji era would have taken a drastically different course, and that if it had not been for Taikan, the movement initiated by Tenshin would not have survived and evolved as it did.

In this sense Taikan, who developed the new *nihonga* from Meiji to Taisho (1912–26) and the present Showa era, was the very embodiment of its spirit. "Embodiment" here means not only that he created a new style of *nihonga* but also that he laid the spiritual foundation on which it was to stand. If we are to consider only the aspect of creating new styles or techniques, there are more interesting artists than Taikan, and, to consider the maturity of artistry alone, Tessai far outshines him. Nevertheless, Taikan has a significance that is absent in Tessai: the significance of squarely grappling with the tasks of the Meiji era, which was an era of great change.

Although there is a tendency to think of the term *nihonga* as having been handed down from ancient times, actually, as we have noted earlier, it is a product of the Meiji era, and it is still used today to distinguish Japanese-style painting from *yoga,* or Western-style painting. We often encounter people who maintain that it is ridiculous to make such a distinction in painting. There may be some justice in such a view, but to point out the existence of a duality in painting alone is to be too abstract and conceptual, for it is necessary to consider all aspects of modern Japanese society in this respect. For example, we may ask, is it wrong that we have both Japanese-style garments (kimonos) and Western clothing? Is it a sign of backwardness that we have both Japanese food and Western food? Are we to be ashamed of having both Japanese-style rooms and Western-style rooms in our houses? Perhaps it is desirable that the two versions of all these things commingle and that the distinctions be lost, but to force such a unification would be meaningless, if

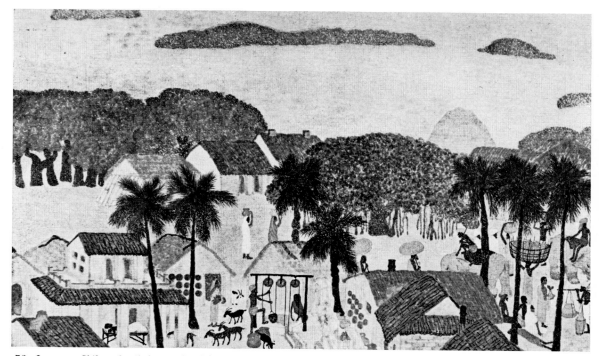

72. *Imamura Shiko: detail from a hand scroll entitled* Tropical Countries. *Colors on paper; dimensions of entire scroll: height, 45.9 cm.; length, 10 m. 1914. Tokyo National Museum.*

not impossible. The two exist in their own right, and it would be a great loss if one were to preclude the other. The duality of Japanese and Western modes in Japan originated in the Meiji era, and it was in that age that Tenshin's movement gave a new and positive meaning to the continued existence of *nihonga*. As a mainstay of this movement, Taikan championed the ideals of *nihonga* as an Oriental art form distinct from *yoga* and brought about its renovation and expansion. Indeed, he spent a lifetime in it, serving as its very backbone. The old saying "If I am still correct after deep reflection, I shall go even against a thousand men," which he was fond of quoting, vividly conveys the vigor and ambition of the intrepid Taikan, a heroic figure of the Meiji age as well as an Oriental romanticist.

TENSHIN'S IDEALS It was Okakura Tenshin who infused Taikan's fighting spirit with lofty idealism. In a lecture he delivered at the Congress of Art and Science, on the occasion of the Louisiana Purchase Exposition in St. Louis in 1904, he made the following remarks about the status quo of Japanese art:

"A great battle is raging among us in the contest for supremacy between Eastern and Western ideals—with what results time alone can determine. I am aware that sincere lovers of art in the West have always emphatically urged us to the preservation of our national style. I have heard many wonder why we should have tried to imitate you in painting as in everything else. You should remember, however, that our wholesale adoption

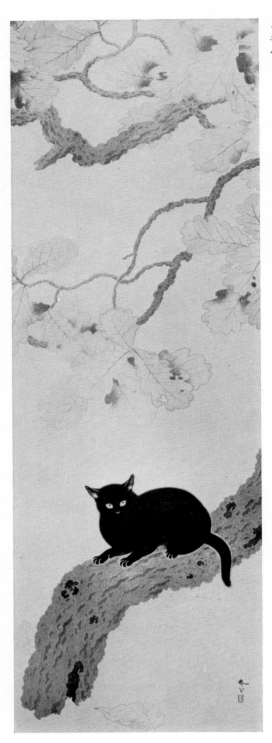

73. *Hishida Shunso:* Black Cat. *Colors on silk; height, 151 cm.; width, 51 cm. 1910. Eisei Bunko, Tokyo.*

74. *Takeuchi Seiho: right-hand screen of a* ▷ *pair of sixfold screens entitled* Deer in Summer. *Colors on silk; dimensions of each screen: height, 177.5 cm.; width, 375 cm. 1936. Atami Art Museum, Shizuoka Prefecture.*

of your methods of life and culture was not purely a matter of choice but of necessity. The word 'modernization' means the occidentalization of the world. The map of Asia will reveal the dismal fate of the ancient civilizations that have succumbed to the spell of industrialism, commercialism, imperialism, and what not, which the modern spirit has cast over them. It seems almost imperative that one should mount the car of Juggernaut, unless one would be crushed under its wheels. Socially, sympathy toward painting, as toward all other questions of life, is divided into two camps—the so-called progressive and the conservative. The former believes in the acceptance of Western culture in its entirety, the latter with a qualification. To the advocates of the wholesale westernization of Japan, Eastern civilization seems a lower development compared to the Western. The more we assimilate the foreign methods, the higher we mount in the scale of humanity. They point out the state of Asiatic nations and the success of Japan in maintaining a national existence by the very fact of recognizing the supremacy of the West. They claim that

civilization is a homogeneous development that defies eclecticism in any of its phases. To them, Japanese painting appears as one with the bows and arrows of our primitive warfare—not to be tolerated in these days of explosives and ironclads.

"The conservatives, on the other hand, assert that Asiatic civilization is not to be despised; that its conception of the harmony of life is as precious as the scientific spirit and the organizing ability of the West. To them, Western society is not necessarily the paragon which all mankind should imitate. They believe in the homogeneity of civilization, but that true homogeneity must be the result of a realization from within, not an accumulation of outside matter. To them, Japanese paintings are by no means the simple weapons that they describe, but a potent machine invented to carry on a special kind of aesthetic warfare." (From "Modern Art from a Japanese Point of View," published in the *Quarterly Review*, vol. 11, no. 2, July 1905, and reprinted in *The Heart of Heaven*, a collection of Okakura's writings published in Tokyo by the Nihon Bijutsuin in 1922.)

It is clear which of the two courses Tenshin advocated for Japanese art. In defending *nihonga,* which in his lecture he likened to "the bows and arrows of our primitive warfare," he was trying to promote the concept of harmony in life that is so uniquely characteristic of Asian arts. What he conceived of was an escape from the folly of getting entangled in the Western ways of life and culture that Japan had perforce adopted on a large scale. He was seeking a means of making a contribution to world culture by preserving what was no less important, if not even more important, to man than the scientific mind and the ability to organize. This must be the role of Meiji art, he thought, if it was to have any meaning in world culture.

Taikan inherited this concept, and by modernizing *nihonga* as an Oriental art form and making occasional use of Western techniques, he endeavored to carry through the spirit of *nihonga.* He was a Meiji man in the sense that he accepted naturalism, a characteristic of nineteenth-century Western-style painting in Japan. He was even more a Meiji man in that he turned away from the mainstream of *ni-*

75. *Maeda Seison: detail from* Ashura. *Colors on paper; dimensions of entire painting: height, 198 cm.; width, 130.5 cm. 1940. Tokyo University of Arts.*

76. *Ogawa Usen: detail from* Autumn on an Island. *Ink on paper; dimensions of entire painting: height, 112.2 cm.; width, 96.2 cm. 1932.* ▷

honga as it came down from the Edo period and tried, instead, to establish a relationship with the picture scrolls, the ink paintings, and the imported Sung paintings of earlier times.

Thus the course that Tenshin's group followed was that of the "third belt" in contrast, on the one hand, with the restoration of *nihonga* in the tradition stemming from the Edo period and, on the other, with the importation and study of Western naturalism. The adoption of such a course represented both a criticism and a synthesis of the other two currents. It is in this respect that the art of the Tenshin group is characteristic of the Meiji era, and it is easily understandable that the art of Taikan, its most prominent painter, fell within the framework of Oriental neoclassicism, with a catalytic influence from nineteenth-century realism. Neoclassicism in this sense was to be brought to maturity in stricter and more finely wrought fash-

ion by the artists of the restored academy. The works of its representative artists—for example, Yasuda Yukihiko, Kobayashi Kokei, Maeda Seison, and Hayami Gyoshu—although all based on *yamato-e,* are variations and expansions of Taikan's art. These later painters were superior to Taikan in style and technique, but in spirit and scale it was Taikan, their forerunner, who undeniably had the greater force.

TAIKAN AND TESSAI If the new *nihonga* signified the advent of Oriental neoclassicism, the art of Tomioka Tessai had an earlier start. He began before there was a *nihonga-yoga* distinction and developed his art with its unity intact. His style was that of *nanga,* the Japanese version of Chinese literati painting, with a slight influence from *yamato-e.* While his work was based on the spirit of the orthodox Oriental literati, he also

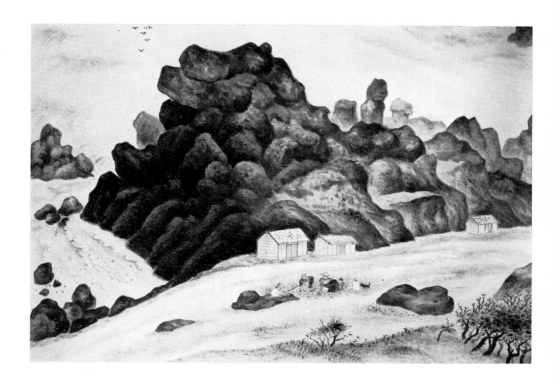

assimilated the realism of the modern age. The fact that Tessai's solidly composed and harmonious paintings displayed a serenity and a density not seen in the adventurous and romantic paintings of the high-pitched Taikan style attests to the difference in background between the two. Taikan's painting has the exhilarating distinctive feature of showing his opposition to *yoga*, but in the painting of Tessai there is a sensual richness that links it with the perceptions of the *yoga* artists. Here, quite literally, was the natural realization of a realm in which *nihonga* and *yoga* had not yet been separated.

The difference between Tessai and Taikan may have been related to the difference between the two cities where they followed their careers—Tessai in the old capital of Kyoto and Taikan in the new capital of Tokyo. The confrontation between *nihonga* and *yoga* was most evident in Meiji-era Tokyo, where modernization and ultranationalism

clashed with each other, and therefore the distinction between the two became the keynote for subsequent art activities centered in that city. In short, both classicism and Westernization were in a certain sense foreign to Tokyo, and in this respect neither Taikan nor Kuroda Seiki stemmed from the main line of Japanese culture. The one deliberately became a traditionalist, while the other deliberately became a plein-airist.

In Kyoto, however, the influence of centuries-old tradition was evident even among Western-style painters, as it was in the case of Umehara Ryuzaburo and others. While there was no connection between Taikan and Kuroda, there were natural ties between Tessai and Umehara. Herein lies the great difference between the artists of Tokyo and those of Kyoto, and it is for this reason that Taikan's work, in comparison with Tessai's, is so typically a product of the Meiji era. We must not over-

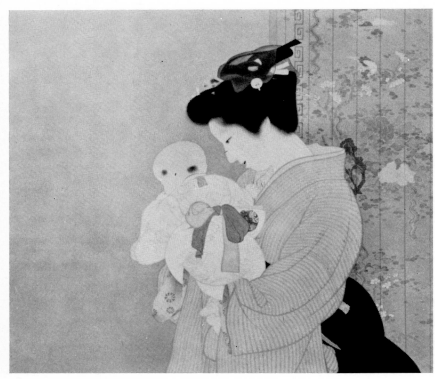

77. Uemura Shoen: detail from Mother and Child. *Colors on silk; dimensions of entire painting: height, 168.5 cm.; width, 116.5 cm. 1934. Tokyo National Museum of Modern Art.*

look this difference in character, which still stands out clearly even if we make a comparison with such members of the restored academy in the next generation as Kokei, Gyoshu, and Murakami Kagaku.

ACADEMY PAINTERS OF THE SECOND PERIOD

The academy experienced some bad days in the late Meiji era, but in 1914 it was reorganized, and a number of new artists came to the fore. Chief among them were Imamura Shiko (1880–1916; Fig. 72), Yasuda Yukihiko (1884–; Fig. 115), Kobayashi Kokei (1883–1957; Figs. 53, 114), Maeda Seison (1885–; Fig. 75), Hayami Gyoshu (1894–1935; Figs. 55, 71), Tomita Keisen (1879–1936), and Ogawa Usen (1868–1938; Fig. 76).

These men might be considered the second wave of academy artists, although the first five had more or less direct links with Okakura Tenshin. In contrast with Taikan and Shunso, they all took as their point of departure the *yamato-e,* that utterly Japanese form of painting from which the severity of classic Chinese styles is completely missing. These new painters liked bright colors, warmth, and softness of line and form, and these qualities set them apart from the Kano tradition, from which the new Japanese painting had begun.

To be sure, it was precisely because of the strictness of the Kano school with respect to linear drawing that Taikan and Shunso had felt obliged to experiment with nonlinear methods. The later artists were far enough removed from the Kano lineage to be able to adopt a more flexible approach toward a new Japanese style. Most of them leaned toward the decorative manner of the Sotatsu-Korin school, and as a result their works have a warmth and a

brightness not found in those of the three earlier leaders of the academy group.

Despite this difference the second wave of artists remained faithful to the ideals of Tenshin in that they studied the classics while remaining receptive to the new ideas of their time. We see here the difference between the activism of the Meiji era and the calmer and in many ways more confident period that followed immediately afterward. The new artists developed a neoclassicist style that was notable for its clarity and maturity, but their paintings lacked the strength and scale of those of the first period. In this sense it may be said that the art of the Tenshin group reached an acme between 1910 and 1920 and subsided into maturity in the academy exhibitions of the past three decades. As we look back at this development, it appears that at the beginning the academy artists were distinctly of the Individualist mode but that in the second phase they grew closer to the Reformist spirit of Maruyama Okyo, at the same time acquiring a classic ideal different from Okyo's realism. It was particularly unfortunate for the academy that both Hishida Shunso and Hayami Gyoshu died young, for both of them seemed to have elements of an intellectual and realistic expressionism that might have opened many new vistas.

The activity of Tenshin and his followers had a profound effect on the Japanese art of their time, and at least until the 1930s the new Japanese style was more popular and influential among working painters than were styles imported from the West. The function performed by Tenshin and the academy was of a different character from that carried out by the proponents of Western art, but their efforts to create a new type of art, both creative and in line with the tradition of the past, earn them a prominent place in the history of modern Japanese art.

THE KYOTO SCHOOL Among the various groups that were influenced by the Tenshin tradition but nevertheless developed in different channels of their own, the most important is the Kyoto school. As we have noted in Chapter One, in the latter part of the Edo

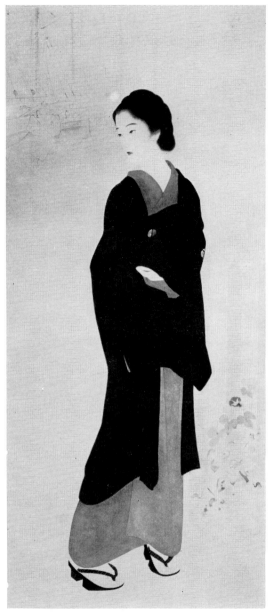

78. *Kaburagi Kiyokata:* Akashicho in Tsukiji. *Colors on silk; height, 174 cm.; width, 74 cm. 1927.*

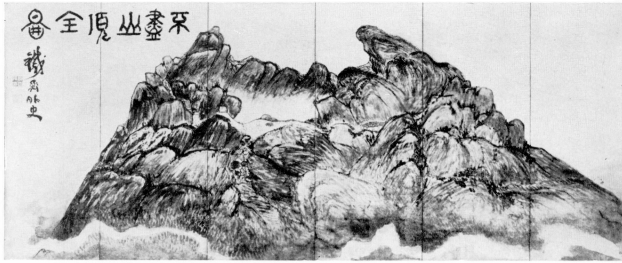

79. *Tomioka Tessai:* The Summit of Mount Fuji. *A sixfold screen; colors on paper; height, 154.5 cm.; width, 359.5 cm.* *1903. Seikojin Hyakurenkai, Hyogo Prefecture.*

period Maruyama Okyo took an important step toward the modernization of Japanese painting by introducing elements of Western perspective and realism. Okyo was followed by Matsumura Goshun (1752–1811), who, along with his disciples, made up what was known as the Shijo school, the name being that of the district in Kyoto where Goshun lived. The Maruyama-Shijo group remained centered in Kyoto, but its influence was felt throughout the country in the late Edo period. In modern times it has been succeeded by the Kyoto school, whose first great leader—and at the same time the last great painter of the Shijo school—was Takeuchi Seiho (1864–1942; Figs. 56, 74).

Almost as distinguished among the Kyoto artists as Takeuchi were Kikuchi Homon (1862–1918), also of the Shijo school, and Yamamoto Shunkyo (1871–1933) of the Maruyama school. These three were doubtless stimulated by the work of Tenshin's group, but their ideas of what should be done to the Japanese style were different from Tenshin's. Takeuchi went to Europe in 1900 and discovered in the works of Corot and Turner a mode of expres-

sion that seemed to him to have many points in common with Oriental painting. After returning from Europe he explored the possibilities of a new naturalism with Japanese overtones. He wrote: "While in Europe, I exchanged opinions with two or three painters, and it did not seem to me that there was much difference between what Europeans see and what we see. In the past the painting methods of Orient and Occident have been different, but one cannot overlook a certain spiritual link. Even in the subjective painting of the Orient, one cannot paint the true nature of something until one understands its actual form. The first step, therefore, is to learn the basic organization of form. After that, it is possible to grasp the overall meaning of things. In Japan today, however, what passes for subjective Oriental painting is a matter of copying old styles: the brush moves along by habit, and there is concern only for rules. It happens that in our times both the Orient and the Occident are concerned with subjective painting, but the Western painters are proceeding along a fundamentally sound path, while Japanese painters are blindly

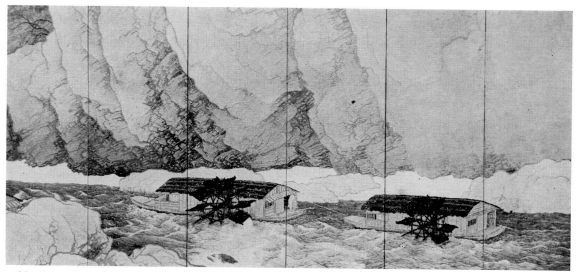

80. *Kawai Gyokudo: left-hand screen of a pair of sixfold screens entitled* Departing Spring. *Colors on silk; dimensions of each screen: height, 166 cm.; width, 360 cm. 1916. Tokyo National Museum.*

following the rules that have been inherited, without examining the fundamental causes and effects. If Japanese painting is to develop, we must make up for our short points by adopting the better features of European painting."

This attitude toward subjective painting and toward the basic need for research had a strong influence on the painters of the Kyoto school, who looked upon Takeuchi as their leader, and it continued as an undercurrent in the next generation. After the establishment of the Ministry of Education Exhibition (Bunten), there was a new appreciation of the skills of the Kyoto painters. Takeuchi was followed by Kikuchi Keigetsu (1879–1955), Nishiyama Suisho (1879–1958), Uemura Shoen (1875–1949; Fig. 77), Hashimoto Kansetsu (1883–1944), and Nishimura Goun (1877–1938).

AN INDEPENDENT GIANT: TOMIOKA TESSAI

In discussing this period it would not do to underestimate the prodigious accomplishments of Tomioka Tessai (1836–1924; Figs. 58, 79), who did not reach the pinnacle of his achievement as a painter until he was in his eighties. The Japanese *nanga* style, developed by Ikeno Taiga (1723–76) and other Edo-period literati, enjoyed considerable popularity during the closing years of Edo and the earlier part of Meiji, but after it was attacked by Ernest Fenollosa, it began to die out. Undaunted by this general development, Tessai, who does not fall easily into any of the classifications of his time, continued the tradition of the scholar-painter and turned out numerous paintings of great distinction, full of personality and intelligence. To the *nanga* tradition he added a beautiful element of coloring that was presumably related to the *yamato-e* tradition, and he achieved a degree of originality and grandeur rarely found among modern artists. In an age when it appears that modern Japanese art had been thrown into turmoil by its exposure to Western art, Tessai's work blooms like a great flower in a place all its own. As one stands before it in amazement, one cannot help wondering if all the intensive activity among the other artists was really yielding anything of value. In comparison

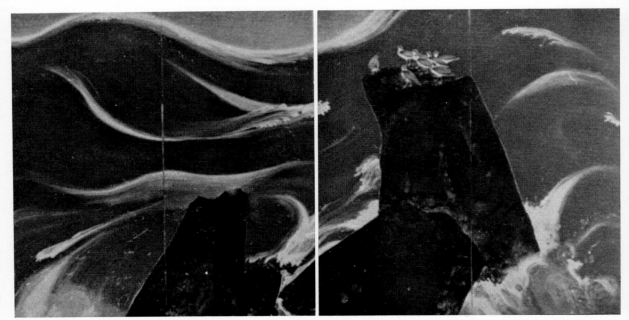

81. Hirafuku Hyakusui: Stormy Shore. *A pair of twofold screens; colors on silk; dimensions of each screen: height, 142.4 cm.; width, 151.5 cm. 1926. Tokyo National Museum of Modern Art.*

with the serenity and composure of Tessai's world, even the activity of Tenshin's group begins to seem like a movement deriving its fundamental inspiration simply from the impact of Western art. One can only say that Tessai reveals a protean strength that was dormant in the painting circles of Kyoto.

OTHER INFLUENTIAL PAINTERS

Among the painters active in the second decade of the twentieth century, we should take note of Kawai Gyokudo (1873–1957; Fig. 80), whose peaceful Japanese landscapes often graced the government exhibitions in Tokyo, and of the artists of the Kinreisha (Golden Bell Society) group, who included Kaburagi Kiyokata (1878–1972; Fig. 78), Hirafuku Hyakusui (1877–1933; Fig. 81), Kikkawa Reika (1875–1929), Matsuoka Eikyu (1881–1934), and Yuki Somei (1875–1957). Kiyokata's literate portrayals of Meiji manners and customs and Hyakusui's refreshing sense of reality represent a new level of growth in the modern Japanese style—a level arrived at by way

of a different path from that followed by the Tenshin disciples. In Kyoto the newer artists like Tsuchida Bakusen (1887–1936; Fig. 70) and Murakami Kagaku (1888–1939; Fig. 57) formed a society of their own—the Kokuga Sosaku Kyokai (National Painting Creation Society)—for the purpose of breaking away from the old Shijo school and creating more modern versions of traditional Japanese styles. In some respects their movement was similar to that of the second generation of the Tenshin followers.

There is no room here to go into detail about the styles developed by these various artists. In general, the development of modern Japanese-style painting after Meiji was a series of waves of action and reaction involving the Tenshin group and its later followers or detractors. Many of the latter-day followers of Tenshin developed individualistic styles that gradually departed from the original Tenshin movement, but in a brief discussion of the broad trends of the time, the subplots and sub-subplots can only be glossed over.

CHAPTER FOUR

From 1910 to 1925

THE INTRODUCTION OF NEW EUROPEAN ART From 1910 to 1923 a group of liberal, humanistic writers, including Mushanokoji Saneatsu (1885–), Shiga Naoya (1883–1971), Satomi Ton (1888–), Arishima Takeo (1878–1923), and Nagayo Yoshio (1888–1961), published a literary journal called *Shirakaba* (White Birch), which, by stressing such themes as love for mankind, respect for human beings, and the goodness of human nature, set the tone for much of the literature and thought of its age. *Shirakaba* incorporated many of the features of an art magazine, for it not only published translations of famous writings on such artists as Cézanne and Rodin but also introduced unusual works of European art in each issue and sponsored exhibitions centered on reproductions of works by impressionists and postimpressionists. It played an important role in familiarizing Japanese artists with Manet, Gauguin, Van Gogh, Renoir, Matisse, Cézanne, and Rodin—particularly these last two, whose works were to have a tremendous influence in Japan in later years.

It would be an exaggeration to say that *Shirakaba* was the first or the only introducer of the newer art from Europe, for in the years around 1910 a host of young artists who had been studying in Europe returned to Japan after having been exposed to Renoir, Cézanne, pointillism, and other powerful influences of the postimpressionist school. In 1908 there were Saito Yori (1885–1959) and Ogiwara Morie (1879–1910; Figs. 6, 106). In 1909 there were Takamura Kotaro (1883–1956; Figs. 82, 85), Yanagi Keisuke (1881–1923), and Tsuda Seifu (1880–). In 1910 there were Yamashita Shintaro (1881–1966), Arishima Ikuma (1882–), Fujishima Takeji, and Minami Kunzo (1893–1951). The return of these artists was followed only shortly thereafter by that of two of the most famous Japanese exponents of modern European painting, Umehara Ryuzaburo (1888–; Figs. 9, 100, 101, 110–12, 118) and Yasui Sotaro (1888–1955; Figs. 40, 96–99), and that of other painters like Saito Toyosaku.

Articles on the new art of Europe began to appear in a number of publications other than *Shirakaba*. In 1909 Shimamura Hogetsu published an article in the *Waseda University Literary Journal* on the latest styles of European painting, and in the same year Saito Yori wrote about his own views concerning the new European art in the magazine *Nihon Oyobi Nihonjin* (Japan and the Japanese). In a well-known journal called *Subaru* (Pleiades), Takamura Kotaro translated Matisse's theories on painting, and in 1910 he excited much interest among the newer Japanese artists with a critical article in the same magazine entitled "Green Sun." Taking as his starting point a painting by Yamawaki Shintoku (1886–1952) entitled *Morning at the Railway Station* (Fig. 45), which had been displayed at the government exhibition in the previous year, Takamura proceeded to set the stage for a movement away

82. *Takamura Kotaro:* Hand. *Bronze; height, 39 cm.*
1923. Tokyo National Museum of Modern Art.

to find a different view of nature from my own. I prefer to consider how this artist has arrived at the nucleus of nature and how he has fulfilled his personal feelings. It does not matter to me if two or three people paint something called a 'green sun,' because I might from time to time see the same thing myself."

This view carries Kuroda Seiki's respect for the artist as an individual a step further and recognizes limitless authority for individuality. It is a gallant insistence that the primary emphasis must be on the fulfillment of the artist's own feeling—an enlightening and passionate call for individualism or subjectivism or self-consciousness as the focal point of modern art.

PHILOSOPHICAL AND LITERARY ORIENTATION

That the literary magazine *Shirakaba* actively promoted the works of the impressionists and postimpressionists was no accident, for this individualistic tendency in the arts, focused as it was upon the search for the self, the deepening of subjectivity, and the delving into inner personal truth, agreed with the magazine's fundamental philosophy. Indeed, *Shirakaba* was looking at the new art from the philosophical and literary viewpoints, and from this angle there was no great difference between the impressionists and the postimpressionists or between them and the fauvists. The point about Renoir, Matisse, Cézanne, Van Gogh, and Gauguin was not so much a matter of the variations in their artistic styles as the insistence of all upon individualistic expression, and in Japan during this age the individualism of these artists agreed with the newest trends in thought and literature. The *Shirakaba* movement had a great influence on Japanese artists, and this was only natural. Indeed, it was probably because of the magazine's philosophical and literary orientation that the new philosophy of art appealed so greatly to the younger artists of the time. It may even be that the spirit of freedom and individualism in the art of the Taisho era sprang from the somewhat loose and lyrical mode of expression that the magazine represented. To some extent the artists discovered a new dream in the

from impressionism toward a more modern and individualistic art. He said, in part:

"I am seeking absolute freedom in art. I recognize the infinite authority of the artist's personality. In every sense I want to think of art from the viewpoint of one single human being, and I want to evaluate a work by starting from consideration of the personality. I want to study the personality as it is and not to admit a great number of doubts. If I think of something as blue and someone else sees it as red, criticism should start from the point of view that this person sees the object as red and then confine itself to the question of how the red is treated. I see no reason to go on complaining because the artist sees the object differently from the way I do. Instead, I consider it a pleasant surprise

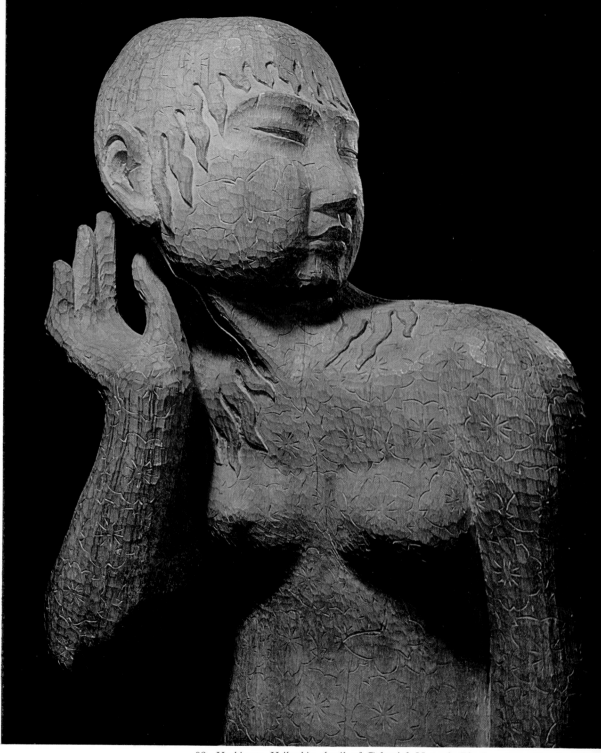

83. Hashimoto Heihachi: detail of Celestial Nymph Playing in a Garden. *Colors on wood; height of entire statue, 121.5 cm. 1930. Tokyo University of Arts.*

85. *Takamura Kotaro: detail from bust of Kuroda Seiki. Bronze; total height, 53.5 cm. 1931. Tokyo National Cultural Properties Research Institute.*

◁ *84. Fujikawa Yuzo: Suzanne. Terra cotta; height, 19 cm. 1909. Tokyo National Museum.*

86. Kawai Kanjiro: bottle
with medallion design of
flowering plants on cinnabar
ground. Height, 29 cm. 1927.
Japan Folk Crafts Museum,
Tokyo.

87. Tomimoto Kenkichi: jar with gold-and-silver design of diamonds and four-petaled flowers on vermilion ground. Height, 27.4 cm. 1962.

88. *Munakata Shiko: detail from* All Sentient Beings. *Woodblock
print; dimensions of entire work: height, 2.27 m.; width, 12.12 m. 1957.*

89. *Hamada Shoji: large bowl with design in black on* namako *(sea cu-* ▷
cumber) ground. Diameter, 56.5 cm. 1962.

90. Kitaoji Rosanjin: plate with striped design on red ground. Diameter, 30.7 cm. 1950.

humanism and idealism of *Shirakaba,* and this new dream became a new wave in the art of the time.

THE EXHIBITIONS OF THE FUSAIN SOCIETY

The new emphasis on freedom was given concrete expression in 1912 at the first exhibition of the so-called Fusain Society, or, as its founders named it, La Société du Fusain. The new call had already been sounded in the previous year by an exhibition of the Absinthe Society, whose leaders, Yorozu Tetsugoro (1885–1927; Figs. 37, 94, 95) and Hiroshima Shintaro (1889–1951), were studying at the Tokyo Art School at the time. Another exhibition had been held in the spring of 1912 by members of the Western Painting Institute, run by the Pacific Painting Society, and still another group had been organized by Kishida Ryusei (1881–1929; Figs. 34, 92, 93), Kimura Sohachi (1893–1958), and other artists and writers who had been influenced by the introductory articles on postimpressionism in *Shirakaba.* Around this time Saito Yori was scheduled to hold a one-man exhibition, but the hall that he had obtained through the Yomiuri Newspaper Company was too big, and even though Kishida Ryusei was also planning a one-man exhibition, it was for some reason impossible that they should share the hall. Consequently, they gathered together the members of the three groups just named and, through their amalgamation, created the Fusain Society. This was the background of the society's exhibition of 1912.

The new tendency of these young artists toward individualism and subjective expression was amply in evidence at the exhibition, but few of the works went beyond attempts to emulate the fauvists and the postimpressionists, and there was a distinctly literary, as opposed to an artistic, flavor. The atmosphere was definitely one of immaturity, but the exhibition, as an expression of the strong passion for the establishment of individualism in art that had led to the organization of the Fusain Society, was significant as a watershed for the art of later times.

The society held a second exhibition in the following year, and it was widely covered by the

91. *Nakamura Tsune:* Portrait of an Aged Voman. *Oil on canvas; height, 98.5 cm.; width, 71.5 cm. 1924.*

press. But the society itself was too heterogeneous to remain in existence very long. Furthermore, although the influence of the postimpressionists and the fauves was evident, and although the exhibition abounded in attempts at personal expression, the necessary technical mastery was lacking. There was the dream, and there was the passion for freedom, but it was more literary and conceptual than real. More technique, more ability, and more time were needed before the new dream and the new passion could take on real form.

KISHIDA RYUSEI

At this point appeared Kishida Ryusei, an important talent who crystallized the new literary art into a style of his own. In 1915 Kishida was the leader of the first exhibition of a new society called the Sodosha, and

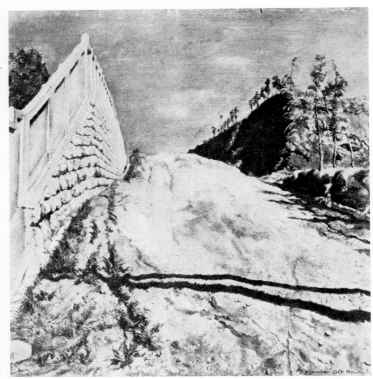

92. *Kishida Ryusei:* The Cut. *Oil on canvas; height, 55.3 cm.; width, 53.7 cm. 1915.*

as time went on, he plunged deeply into a minutely realistic style that came to be known as the Sodosha style. Of his own experiences, he wrote:

"I was given my own consciousness of my work by the artists of the postimpressionist school, particularly Van Gogh and Cézanne, and as a result my early works were profoundly influenced by this group. Later I concerned myself more with the theory behind their works and attempted to discover the essence of their simplification of color and form. Somehow, however, no matter how much I tried, I was unable to satisfy myself. Instead of suppressing the desire for realism, I found that the more I simplified, the more I became aware of realism. I was dissatisfied because my work seemed to be gradually separating itself from the modern tendency. Still, there was no way for me to proceed except to follow my own desires and instincts. In

this fashion I gradually came to feel something that only I myself could feel, and I drew further away from the influence I had originally felt until I reached the point of painting as I do today.

"And yet, no matter how far my paintings may be from contemporary trends, and no matter how close they have come to the classical European style, I have profound respect for Van Gogh and Cézanne. Indeed, I feel that I have greater understanding of them and greater respect for them than in the stage when I was under their direct influence. And I am still learning a profound teaching from them.

"This is true because I have been taught by them to regard nature in accordance with the demands of my own inner spirit. I was shown by them for the first time a concept of art as a means of expressing my own inner self. Since then I have gradually

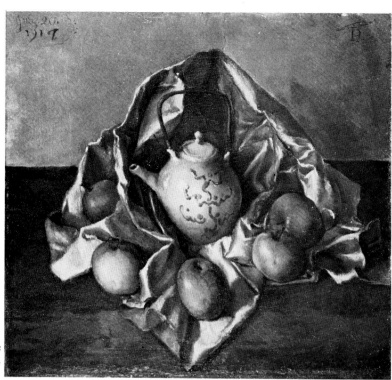

93. Kishida Ryusei: Still Life. *Oil on canvas; height, 45.5 cm.; width, 45.2 cm. 1917.*

become my true self, and I have opened up a path of my own. This does not mean, however, that I have separated myself from them. On the contrary, I feel myself compelled to respect them even more."

Here we see an extremely effective realization of the concept of art expressed in *Shirakaba*. Nothing could have been easier in the wake of the postimpressionists and the fauves than simply to adopt on a superficial level their colors and forms. But to Kishida the real problem was to be able to look at nature "in accordance with the demands of my own inner spirit" and to find a way of art that would enable him to express his own inner feelings. This was the true revelation brought to him by the art of Van Gogh and Cézanne.

Kishida departed from the superficial trend toward modernism and approached the immaculate realism of classicism. His stubborn pursuit of his own individual goal was one of the most laudable expressions of the attitude that underlay Taisho-era art. In him we can see a new expression of the Individualistic trend in modern Japanese painting.

Rejecting the imitative style inspired by the postimpressionists and the fauves, Kishida drew closer instead to the classic beauty of northern European artists like Dürer and Van Eyck, and in doing so he produced such excellent works as his *Still Life* of 1917 (Fig. 93) and his numerous portraits of his daughter Reiko (Fig. 34) and young country girls. In his later years he adopted elements from the early ukiyo-e paintings as well as from the paintings of the Chinese Sung and Yuan periods. Eventually he arrived at a sort of *nanga* style in oils that was his very own. In terms of the three broad classifications employed in this book, we have described him as an Individualist, but he also demon-

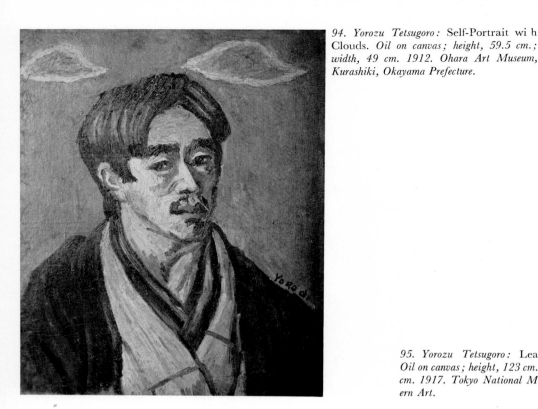

94. *Yorozu Tetsugoro:* Self-Portrait wi h Clouds. *Oil on canvas; height, 59.5 cm.; width, 49 cm. 1912. Ohara Art Museum, Kurashiki, Okayama Prefecture.*

95. *Yorozu Tetsugoro:* Leaning Person.
Oil on canvas; height, 123 cm.; width, 100.9 cm. 1917. Tokyo National Museum of Modern Art.

strated the better features of the Occidentalists and the Reformists. He did not escape the rather stunted quality—the littleness—that had characterized the Individualists of earlier times, but in a certain sense this is perhaps proof of the sincerity of his art, for such littleness was present in the works of all modern Japanese artists of this age who were not purely imitative.

INFLUENTIAL ARTISTS OF THE NIKA SOCIETY In contrast with Kishida's painting, the new Occidentalism represented by the Fusain Society became more and more the major trend of art in the Taisho era. The principal stage for this development was the Nika (Second Division) Society, a group of dissident artists who broke off from the Ministry of Education Exhibition of 1914. The artists of the

Nika Society brought in first one and then another of the newer styles from Europe, and although their importations tended to be purely imitative, they nevertheless furnished a new impetus to the Japanese art world as a whole. Furthermore, among the Nika Society members there were several who were able to adopt an independent position and add substance to the new models brought from Europe, thus contributing considerably to the development of a new spirit of individualism. The most influential of the new artists were Umehara Ryuzaburo, Yasui Sotaro, and Sakamoto Hanjiro (1882–1969), but Yorozu Tetsugoro, Sekine Shoji (1899–1919), and Koide Narashige (1887–1931; Figs. 38, 109) were also significant contributors to this group. On the sidelines, as it were, were Kosugi Misei (1881–1964), who organized the Shun'yo (Spring Sun) Society from members of the Western-

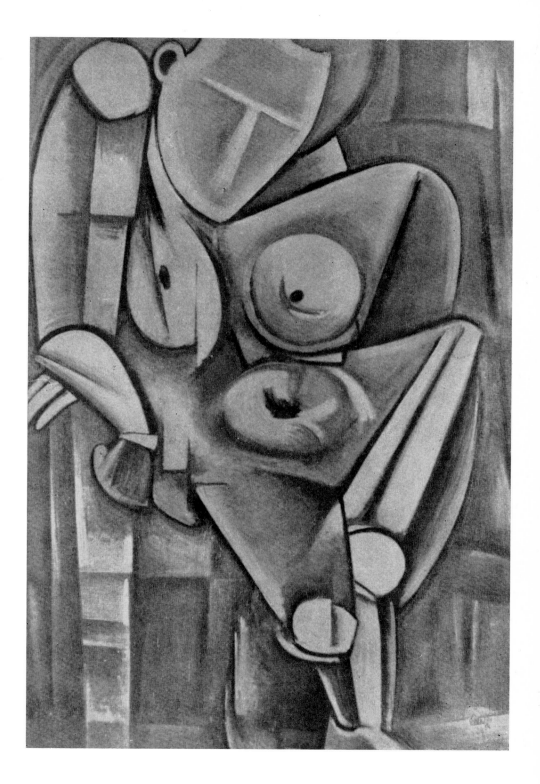

96. Yasui Sotaro: Roses. *Oil on canvas; height, 60 cm.; width, 52 cm. 1932.*

97. Yasui Sotaro: Master Yokoyama Taikan. *Oil on canvas; height, 33.4 cm.; width, 24.3 cm. 1946.*

style-painting group of the Japan Art Academy Exhibition, and Nakamura Tsune (1888–1924; Figs. 35, 91), who stood out as an independent in the government-exhibition group. All of these artists exerted a strong influence on the art trends of the Taisho era.

Umehara and Yasui are of special interest, not only because they were to become the titans of Japanese art in the succeeding Showa era (1926 to present) but also because their backgrounds throw light on the creation of a genuinely Japanese form of Western-style painting. Umehara's own writings tell much of the formation of the Japanese artist as a young man:

"Our house was by far the largest in Ashikari-yama-cho [in Kyoto]. Our family business was, in short, the dyeing and embroidering of cloth for kimonos. We made designs for the white material that we received from the cloth wholesalers, subcontracted the dyeing and embroidering to other houses, and then delivered the finished kimonos or material to the customers. Nearly every house in the neighborhood was in the same business; so I naturally felt that I owned the block. . . . Today the house and the shop are in different places, but when I was a child, they were both under the same roof, and I was always playing near the place where the men who came to draw the designs were working. I learned what they meant when they spoke of a plum tree or a pine tree in the Korin style, and it seems to me that even before I went to primary school, I had learned that Sotatsu's designs were better than those of Korin. I stayed in this house, where I was born, until I was twenty, at which

98 (above). *Yasui Sotaro:* Landscape with Red Bridge. *Oil on canvas; height, 60.7 cm.; width, 72.7 cm. 1954.*

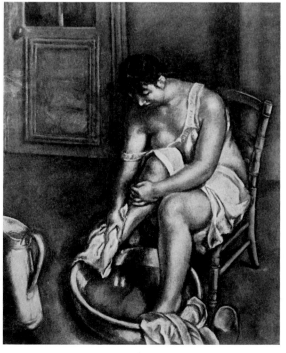

99. *Yasui Sotaro:* Woman Washing Her Feet. *Oil on canvas; height, 116.8 cm.; width, 80.3 cm. 1913.*

100. Umehara Ryuzaburo: The Gold Necklace. *Oil on canvas; height, 46 cm.; width, 44 cm. 1913. Tokyo National Museum of Modern Art.*

101. Umehara Ryuzaburo: Morning Glow. ▷ *Oil on canvas; height, 65 cm.; width, 81 cm. 1937.*

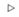

time I went to Europe, and many of my childhood memories are connected with the round of annual events that took place in this house or in the neighborhood around the house."

In other words, even as a child Umehara came under the influence not only of the culture of Kyoto but also of the arts and crafts associated with the making of silk kimonos. This was a grandly decorative craft that had descended from the Muromachi period (1336–1568). Although by Umehara's time it had undergone a considerable decline, what had been lost was primarily the originality and boldness of design, not the beauty. In any event, the young man was familiar with the work of such magnificent artists as Sotatsu and Korin even before he went to primary school.

Umehara was further blessed with tremendous natural talent and had the benefit of studying with

Asai Chu. In the year following Asai's death he went to Paris, where he first visited the Palais de Luxembourg and saw the works of Renoir. Of this experience he wrote: "These pictures! This was what I had been looking for, what I had been dreaming of, what I had been wanting to do. The very sight of them made me feel that it had been worth the trouble to cross the ocean to this distant country."

In February 1909 Umehara went to Cagnes to meet Renoir. What, he wondered, would the great man say at the audacity of this twenty-one-year-old from Japan who arrived out of a clear sky without introduction? Umehara's thoughts on this subject, as recorded in his memoirs of Renoir, are revealing:

"Well, suppose I visited him. What would I do? What would I say? Would he really see me? I have heard that when someone knocks at Degas's door,

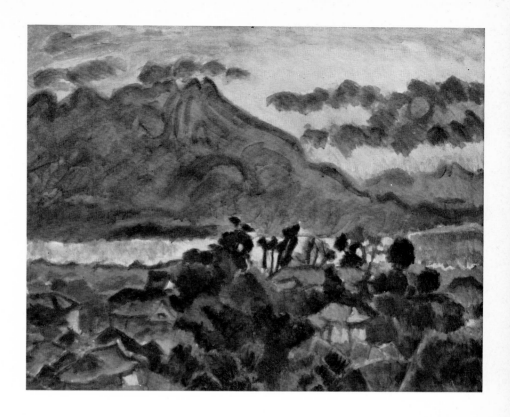

he first opens it a crack, and then if the person is someone he doesn't know or someone he doesn't like, he slams it shut forthwith. How crushed I would be if that sort of thing happened to me! If indeed Renoir let me in, what would I talk about? There I was, not able to speak French as well as a three-year-old child, and I could not hope that anything I might say would be interesting to this marvelous painter. Often I grew timid and concluded that I should not even think of barging in and interrupting this man whom I worshiped. But my desire was stronger than my timidity. Finally I made up my mind I would do it. I was good enough to be received by him. I loved his art so much! He must be made to see that!''

What a touching and at the same time impressive view of a talented young painter! Renoir did indeed receive Umehara, recognized his talent, and in later years grew to consider him his most beloved disciple. And in Umehara's work one sees all the elements: Kyoto, Sotatsu, Korin, Asai Chu, Renoir, modern European art, and the daring that had enabled him to approach the great French artist. We find in Umehara neither stubborn insistence on Japanese tradition nor a groveling attitude toward European art but, instead, great originality and creativity formed from the absorption of many diverse elements into one great and imaginative spirit.

After learning from Renoir that "the strongest and richest harmony among colors is born of the strongest contrast of the weakest colors," he developed and matured his own inborn talent for color, and in the Showa era he absorbed not only elements from the arts of the Momoyama period (1568–1603), *yamato-e*, Sotatsu, and Korin but also

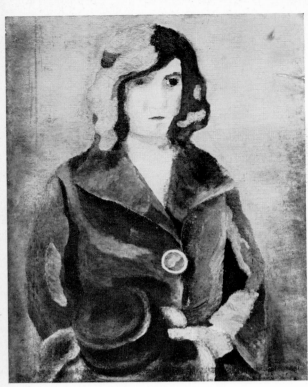

the freedom seen in the works of Ikeno Taiga and Tomioka Tessai, until he achieved an art of his own filled with vitality. It can hardly be an exaggeration to say that only with the appearance of Umehara did Western-style painting since the Meiji era find a place in the current of Japanese art and that a new passage was opened to connect the classic and the contemporary. We are told that when Tomioka Tessai encountered the work of Renoir for the first time, he cried out, "This is it!" Umehara went even further, for not only did he perceive the essence of Renoir's art through his pure youthful instinct but he also mastered the elements of it and unified the Japanese and the Western aesthetic senses. Indeed, it is possible to think of Umehara's work as a gift from heaven.

Kyoto's traditions of life and beauty, which were

the foundation of Umehara's art, brought forth other talents as well. One of these was Yasui Sotaro, who represented the other aspect of the so-called Yasui-Umehara period. Another was Suda Kunitaro, who blended the arts of East and West from his own unique point of view.

Yasui Sotaro was of a background extremely similar to that of Umehara. Ogawa Chikame, a painter who knew both artists, wrote of them as follows:

"When I think of Umehara, I think of the wonderful contrast offered by Yasui Sotaro. Both of them were born in Kyoto in the same year, and both were scions of large merchant houses. Umehara was the son of a silk wholesaler who dealt in *yuzen*-dyed materials, fine *chirimen* crepes, and the like. Yasui was the son of a cotton-goods whole-

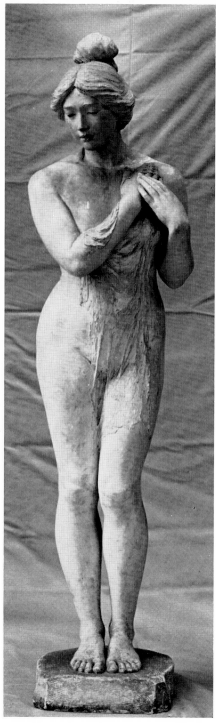

saler. Around the age of seventeen or eighteen, they both went to the Institute of Western Painting, which had been established at the Kyoto Higher School of Industry after the appointment there of Asai Chu and which was the forerunner of the Kansai Art Academy. While they were in school, the two were regarded as the most brilliant students. Aside from their similar backgrounds, they were considered by their contemporaries to be an 'excellently matched pair.' . . .

"Umehara was a handsome young man with a character as smooth as the silk that his father sold. It was the same with his conduct and with the works he painted. By way of contrast, Yasui had the simplicity and sturdiness of the cotton goods *his* father sold, and his pictures were dark and tastefully severe. There was Umehara with his white face, his carefully parted hair, and his glossy silk kimono, talking with the articulate bodily expression of a professional actor. (He was fond of the theater in those days.) Here was the tall Yasui, with his crew-cut hair, walking around shamelessly in the main streets of Kyoto in khaki work clothes splattered with paint—a sight that was indeed unusual in the Kyoto of those days. . . . The contrast was astounding. And then this 'excellently matched pair' went off to Paris at almost the same time."

Yasui studied hard and polished his technique in Paris, receiving much inspiration from Pissarro and Cézanne, and throughout his life his work remained as simple and sturdy as Umehara's did elegant and colorful. Like Umehara, he represents a peak in the Western-style painting of the Showa era. In their work as well as in their personalities, they did indeed make an "excellently matched pair" as the creators of an earnest new Japanese art. And just as in the case of Umehara, Yasui's work constituted both a modernization of Kyoto's sense of beauty and a movement away from it.

The same can be said of Suda Kunitaro (1891–1961; Fig. 42). Suda was born in the heart of Kyoto. It was a perfect environment for him, because he lived in practically the same neighborhood where Yosa Buson (1716–83), Matsumura Goshun, and Maruyama Okyo had lived during the Edo period and where, in modern times, Mori Kansai (1814–

94), Suzuki Hyakunen (1825–91), Taniguchi Aizan (1816–99), Takeuchi Seiho, and Uemura Shoen also lived. Raised in this atmosphere, he became interested in Western-style painting in his boyhood, and, quite appropriately for one born into Kyoto's upper class, he approached it with the closest scrutiny, aided by a tradition of culture and delicate sensitivity. In his memoirs he wrote: "Why has painting developed in different directions in the East and the West? Does this difference mean that our new aspiration should be a synthesis of the two? This was what I wanted to pursue in college." After he had studied aesthetics and art history in college and had then entered the Kansai Art Academy, it was only natural for him to advance toward a higher goal. His European years were spent chiefly in Spain, where he enriched his own tasteful style, and this may account for the difference between his work and that of Umehara and Yasui, but his was also a process of modernizing the Kyoto aesthetic tradition.

It is now clear that the problems in the art world after Meiji—for example, the blending of Eastern and Western concepts of beauty and the development of a new kind of Western-style painting in Japan—owed their solution to Kyoto, its background, and its potentialities. In Western-style painters brought up in the Kyoto tradition—men like Umehara, Yasui, and Suda—there was already an ability to digest a foreign civilization. Of their work, it is Umehara's that stands out as the most brilliant.

During the Taisho era these men back from Europe were rivaled by Sakamoto Hanjiro and Yorozu Tetsugoro, in neither of whose works the direct influence of Europe was so prominent, although of

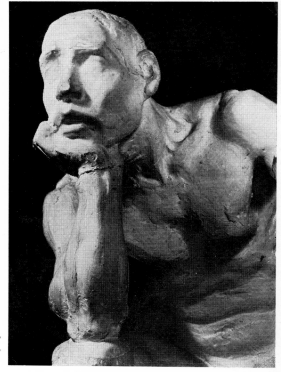

104 (opposite page, left). Nakahara Tei-jiro: Young Caucasian. Bronze; height, 42 cm. 1919. Tokyo University of Arts.

105 (opposite page, right). Tobari Ko-gan: Woman. Plaster of Paris; height, 25 cm. 1918. Tokyo National Museum.

106. Ogiwara Morie: detail of Laborer. Plaster of Paris; height of entire statue, 107 cm. 1909. Rokuzan Art Museum, Nagano Prefecture.

course it was present. Sakamoto (Figs. 39, 102) started out under the influence of impressionism but gradually deepened his own individualistic view of nature and eventually arrived at a style rich in symbolism suggestive of Oriental philosophy. In 1921 he went to France and further developed his technique, but he had already experimented with a black-and-white style of his own, and the foundation of his oeuvre had been formed before his European sojourn. By way of contrast, Yorozu plunged far more boldly into the newer European styles and accepted new forms of expression as they came along. His *Woman in a Wood*, displayed at the Fusain Society exhibition in 1912, was already a work of considerable solidity, and in later years he went on to attempt his own interpretation of fauvism and cubism in such works as *Leaning Person* (Fig. 95) and *Half-kneeling Person* (Fig. 37), both of which showed

a lively new approach. Still later, in his continued search for a new and freer style of expression, he adopted certain elements of *nanga*. Like Kishida Ryusei, he may be classed among the new Individualists, although the direction he took was very different from that of Kishida.

Also to be numbered among the new Individualists is Sekine Shoji, who in his short lifetime tried wholeheartedly to gather all of the new styles unto himself. His *Sadness of Faith* (Fig. 35) may have a somewhat derivative look, but it is original to the extent that it cannot be described as imitative of any particular artist anywhere. Koide Narashige, for his part, falls somewhere in between Yasui and Umehara, and the nudes of a series that he painted in the early Showa era are particularly noteworthy for their fresh and heady loveliness. More in the Reformist vein was the work of Kosugi Misei, and

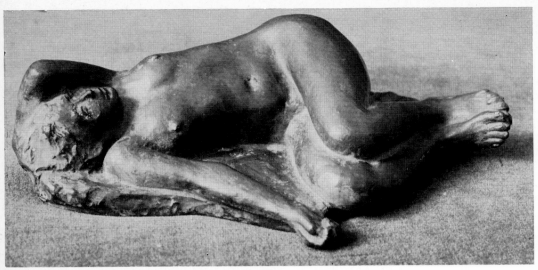

107. *Fujikawa Yuzo:* Nude. *Bronze; length, 31 cm.* 1932.

it is perhaps only natural that he eventually shifted from Western-inspired art to what might be called a new *nanga* style. Nakamura Tsune, who is best known for his *Portrait of Eroshenko* (Fig. 33), based himself on the impressionist style but was strongly influenced by Renoir and Cézanne. His style was open and sincere almost to the point of being pious.

These various artists represent a number of different aspects of the art produced by the spread of the new spirit that characterized the Taisho era. As a result of the experience of this age, Japanese painting in the Western style began to be a legitimate branch of the art in its own right. Or, to put it differently, we see here the beginning of a new age in which individualism and originality outweigh the derivative elements in modern Japanese oil painting.

THE FAUVIST STYLE IN JAPAN

It is important to examine the reasons why fauvism, of all the modern trends in European art, was the one that was most highly favored in Japan. In Europe, where the mainstream of tradition sprang from strict academic realism, fauvism was a destructive, revolutionary movement, and a conscious one at that. In Japan the opposite was the case. Far from being the mainstream of Japanese tradition, academic realism was the conscious revolution undertaken by artists dissatisfied with the past. Strict realism was to some extent softened and made more palatable to Japanese tastes by Kuroda Seiki, and the subsequent trend through postimpressionism to fauvism represented in many ways the rebirth of the freedom that had been seen in the *nanga* and the Maruyama-Shijo styles of traditional Japanese art. To Japanese eyes, in short, it required nothing of the "wild beast" to appreciate the fauves. On the contrary, it was like coming home again. No intense and passionate search for a new ideal or a new understanding was involved. In the fauvist medium the Japanese artist could simply let his Japanese self go. Herein lies the reason for the popularity of fauvism among Japanese artists, as well as the reason why the cubist style never caught on. It should never be forgotten that the historical significance of the fauvist movement in Japan was far different from what it was in Europe. Indeed, fauvism appealed to

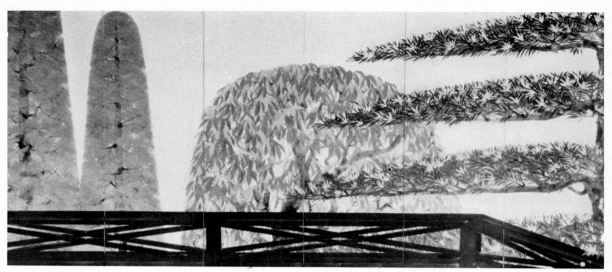

108. Kawabata Ryushi: right-hand screen of a pair of sixfold screens entitled Music of Spring. *Colors on paper; dimensions of each screen: height, 182 cm.; width, 396 cm. 1932. Ryushi Kinenkan, Tokyo.*

Japanese artists for many other reasons than its mere novelty.

NEW TRENDS IN SCULPTURE

The new trends in Western-style painting were only one aspect of a general movement of the times. As we have already seen, in the field of *nihonga* a new individualism, marked by a sort of sweetness-and-light effect, appeared in the Japan Art Academy exhibitions in the Taisho era, and the influence of the postimpressionists was strong on the members of the Kokuga Sosaku Kyokai in Kyoto. This branching out in new directions shows up in sculpture as well, for the introduction of Rodin at the end of Meiji had an effect on Japanese sculpture similar to that of the postimpressionists on painters working in oils.

During the Meiji era the two major trends in Japanese sculpture were those represented by Takamura Kotaro's father, Koun (1852–1834), who shook off the restraints of traditional wooden sculpture, and by the Western-style sculpture that was developed by the students of the art school in the Technological College under the Ministry of In-

dustry. Around 1900, new ideas were introduced by Shinkai Taketaro (1868–1927; Fig. 103), who had studied in Berlin and who spread his ideas through the Western Painting Institute of the Pacific Painting Society. Finally, around 1910, an entirely new trend was begun by several young men who had come under the influence of the art of Rodin.

One of the first of this new group was Ogiwara Morie (Figs. 6, 106), who, having seen Rodin's *Thinker* at the Salon de Paris in the spring of 1904, was so moved by the work that he dropped painting and took up sculpture. In 1908 Ogiwara returned to Japan and devoted much effort toward introducing the new modes in European art, emphasizing the special merits of Rodin and displaying such admirable works as his bronze statue *Woman* (Fig. 6) at the Ministry of Education Exhibition. *Woman* is Ogiwara's masterpiece: a work in which the youthful emotion and the aspiration of the times are captured with startlingly graphic effect. Outwardly, it is a very simple work—almost crude to some eyes—but it is firmly based on the Rodinesque idea that the beauty of true sculpture

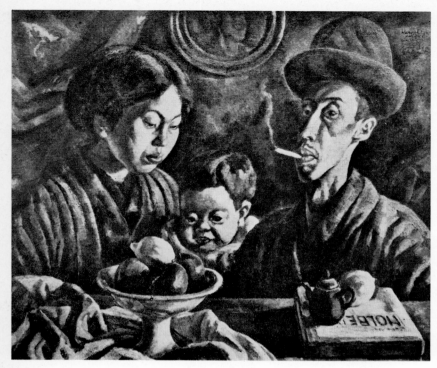

109. *Koide Narashige:* The N Family. *Oil on canvas; height, 77.5 cm.; width, 89.5 cm. 1919. Ohara Art Museum, Kurashiki, Okayama Prefecture.*

lies in inner strength and inner life. Ogiwara was the first Japanese sculptor to give expression to this concept.

By coincidence, in the same year that Ogiwara saw *The Thinker* another young Japanese artist, Takamura Kotaro, was deeply impressed by the same work, as reproduced in a Japanese art magazine. Takamura is well known in Japan for his later translation of Rodin's memoirs in *Shirakaba,* and his own works, though not numerous, represent the highest level of modern Japanese sculpture (Figs. 82, 85). Indeed, it may be said that he was the one Japanese who best understood the true spirit of modern European sculpture.

The art of Rodin also had a deep effect upon Nakahara Teijiro (1888–1921; Fig. 104) and Ogiwara's friend Tobari Kogan (1888–1927; Fig. 105), and through these men the spirit of Rodin was passed on to the sculpture section of the Japan Art Academy. Through Fujikawa Yuzo (1883–1935; Figs. 84, 107) the Rodin style was also transmitted to the Nika Society. In this way, modern styles of Western sculpture permeated the Japanese sculptural world in much the same way as the postimpressionist and fauvist styles dominated the world of painting after the appearance of *Shirakaba.*

The Western influence even provided an impetus for some of the sculptors working in the traditional medium of wood, evoking such neoclassic styles as those of Hiragushi Denchu (1872–) and Sato Chozan (1888–1963). As time went on, a number of new and individualistic styles appeared, most notably that of Hashimoto Heihachi (1887–1935; Fig. 83). As compared with the world of painting, movements in the world of modern sculpture were far less spectacular, but it is certain that the sculpture of the Taisho era was experiencing the same kind of impact from European influences.

CHAPTER FIVE

From Modern to Contemporary

THE CRISIS AFTER THE GREAT KANTO EARTHQUAKE Although the Taisho era did not officially end until 1926, as an age of idealism, individualism, and personal freedom, it came to a close in 1923 with the Great Kanto Earthquake. This earthquake was by no means the strongest ever recorded in Japan, but it was possibly the most calamitous in world history, largely because of the vast fire that followed it. More than 90,000 people lost their lives, and some 3,400,000 suffered damage of one sort or another. Since the disaster occurred in the political and economic capital of the nation, the physical damage was horrendous. It has been estimated that the economic loss alone was no less than 6.5 billion yen, a figure far larger than the national budget in those times, and this loss brought on crises in every phase of Japanese life. The earthquake led to turning points in government, society, and thought. On the one hand, there was an almost immediate upsurge in the labor movement; on the other, there arose a new trend toward faddism and decadence. Both tendencies were reflected in the world of art —the one in a new emphasis on so-called proletarian art and the other in the appearance of an avant-garde concerned with futurism, dadaism, and surrealism. These two new currents were by no means clearly defined at the time, but, like the Fusain Society of the late Meiji era, they constituted a forecast of the directions in which art was to move in the Showa era.

A new and decisive undercurrent brought on a refraction of, and a resistance to, the easygoing individualism and idealism of the Taisho era. Art could no longer go pleasantly along its way, searching vaguely for some universal dream for humanity. The stern facts of social reality now had to be faced. The sentiments of the Taisho era did not all disappear at once but ebbed slowly away like an outgoing tide. It would be no exaggeration to say that sooner or later every work by every artist reflected this change. Perhaps the most striking example can be found in the sweet, lyrical paintings of Takehisa Yumeji (1884–1934; Fig. 117), whose style had dominated a whole generation. It is generally considered that Takehisa's fame came to an end with the Great Earthquake, and this is true, for his world was the world of Taisho. In the new age his pictures took on the appearance of what might be called faded *nanga*: paintings in which there was at times a touch of futurism and at times a bleak loneliness. As paintings, there were many that were not inferior to his earlier works, but the taste for the gentle lyricism that had made him famous was no longer in existence. In a way the colder works of Takehisa's late years are surprisingly symbolic of the feeling that was abroad in early Showa, and it was in Takehisa's late years that Japan began moving toward war.

Taking advantage of the economic depression and the decaying morale of the early 1930s, the Japanese military tightened its hold on the govern-

110. Umehara Ryuzaburo: Autumn Sky in Peking. *Oil on canvas; height, 90 cm.; width, 74 cm. 1942.*

111. Umehara Ryuzaburo: Self-Portrait. *Monochrome; height, 20.9 cm.; width, 18.3 cm. 1945.*

ment, and after the seizure of Manchuria in 1931 the winds of fascism swept over the land. By 1935 the Japanese world of art was concerned more about the reorganization of the Imperial Art Academy (Teikoku Bijutsuin) than it was about anything else, and as the Sino-Japanese War expanded into World War II, art, like everything else, was obscured by the war effort.

THE YASUI-UMEHARA PERIOD

As one surveys the years from 1925 to 1940, it becomes apparent that the modern Japanese art developed during the preceding Meiji and Taisho eras was now attaining maturity. Taisho art had a certain appeal: it was pleasant to look at, and one sensed in it an atmosphere of freedom of spirit and individuality, but it did not go beyond the stage of being "promising." From a technical viewpoint it was lax and rough-

hewn, possibly because the artists had not been subjected to the stringencies of genuine hardship. After the Great Earthquake, artists somehow began to pull their works together, and even though they lost some of the scope and humanistic sentiment of the earlier period, they achieved greater intensity in their own styles, as well as greater discipline and technical proficiency. They were now entering an age in which Western-style painting would be firmly implanted in Japanese soil.

During the 1930s, artists and art critics began to speak of what they called the "Yasui-Umehara period," for by now Yasui Sotaro and Umehara Ryuzaburo had come to be recognized as the leading masters of Japanese Western-style art. It will be remembered that these two men were among the most promising young artists of the Taisho era. By the 1930s both had improved their technique and had become mature artists. As we have noted,

112. Umehara Ryuzaburo: Cannes. Oil on canvas; height, 32.5 cm.; width, 49.5 cm. 1956.

their basic styles were different, but they were alike in that they were able to absorb postimpressionism and the styles that followed it and to create a truly Japanese form of modern Western painting. They were also alike in that they furnished a preview of the Showa individualist, no longer restrained by the littleness that had usually characterized the Individualists of earlier periods.

The starting point for Yasui had been Pissarro and Cézanne, but while trying to probe the depths of realism and, at the same time, abbreviating and simplifying, he arrived at a steady, well-judged, and exemplary style of Western painting. The results of his efforts are evident in many portraits, still lifes, and landscapes, including his well-known *Chin Jung* (Fig. 40).

Umehara's developed style is more naive in appearance than Yasui's, but it is rich in originality and boldness. This might have been predicted from

the story of his origins, for, having started with the training of Renoir, he was in a position to adopt broadly from such Japanese traditions as those of the *yamato-e*, the Momoyama screen paintings, Sotatsu, Korin, and the *nanga*. In form and color alike, he created a world of gorgeousness that reflected the freedom of literati painters from Ikeno Taiga to Tomioka Tessai. His many nudes, his landscapes picturing the volcanoes Sakurajima and Kirishima of southern Kyushu, and his Peking series reveal a new beauty that is perhaps better suited to Japanese sensibilities than the *nihonga* itself.

Other artists who had based themselves on Western painting methods veered toward a more Japanese sense of refinement. We see this, for example, in the horses and still lifes painted by Sakamoto Hanjiro and in the varied paintings of Fujita Tsuguji (Leonard Foujita; 1886–1968; Fig. 113) and even in the later works of Fujishima Takeji. The

same type of amalgamation appears in still later artists like Koide Narashige and his associates.

The Yasui-Umehara period may be viewed as the formative age of the first genuinely Japanese version of modern Western art. This was the logical and inevitable conclusion of the Western-art movement that had started eighty or ninety years earlier.

THE YUKIHIKO-KOKEI PERIOD Simultaneously with the Yasui-Umehara period in Western-style painting, there occurred in the field of *nihonga* the Yukihiko-Kokei period. In a sense these two periods were the opposite sides of the same coin, for while Yasui and Umehara were giving a new Japanese meaning to Western art, Yasuda Yukihiko and Kobayashi Kokei were completing a new link between classical Japanese art and the Japanese art of modern times. Indeed, it may be said that in the works of these two men the modernization of Japanese-style painting was brought to its logical conclusion. Viewed in this light, Yasuda's *Suntzu Leading the Troops* and *The Encampment at Kiseagwa* (Fig. 115) and Kobayashi's *Crane and Turkey* (Fig. 114), *Princess Kiyo*, and *Hair*—mostly works of the late 1930s and the early 1940s—have a close connection with the works that Yasui and Umehara were turning out around the same time.

The same trend toward a completely mature modernization of *nihonga* can be seen in the works of Maeda Seison (Fig. 75), Hayami Gyoshu (Figs. 55, 71), Tomita Keisen, Ogawa Usen (Fig. 76), and Kaburagi Kiyokata (Fig. 78) and in the later works of Hirafuku Hyakusui (Fig. 81). It can also be seen in the last works of such Kyoto painters as

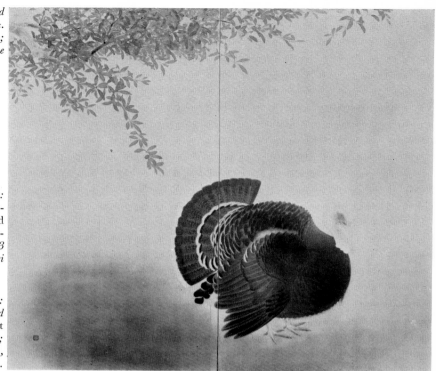

113. Fujita Tsuguharu (Leonard Foujita): House in Dordogne. *Oil on canvas; height, 45 cm.; width, 53 cm. 1940. Bridgestone Museum of Art, Tokyo.*

114 (right). Kobayashi Kokei: left-hand screen of a pair of two-fold screens entitled Crane and Turkey. *Colors on paper; dimensions of each screen: height, 170.3 cm.; width, 191.6 cm. 1928. Eisei Bunko, Tokyo.*

115 (below). Yasuda Yukihiko: right-hand screen of a pair of fourfold screens entitled The Encampment at Kisegawa. *Colors on paper; dimensions of each screen: height, 167.5 cm.; width, 372 cm. 1941.*

116. Saeki Yuzo: Billboard. *Oil on canvas; height, 72.7 cm.; width, 60 cm. 1927. Bridgestone Museum of Art, Tokyo.*

117. Takehisa Yumeji: Record of Youth. Oil on canvas; height, 47 cm.; width, 46 cm. About 1930.

Tsuchida Bakusen (Fig. 70) and Murakami Kagaku (Fig. 57). All of these painters at one time or another achieved the same spiritual intensity and loftiness as Yasuda and Kobayashi, but it was these two men who were regarded as the pacemakers in the field.

In short, the period from 1925 to 1940 represented the culmination of the work done in the previous seven or eight decades. Western painting had been Japanized, and the Japanese painting of the past had been modernized. Furthermore, it can be said that there was balance and harmony between the two.

Mention should also be made of Goto Shintaro and his Seiko Society, which during these years functioned as an independent group having connections with both Western art and *nihonga*. Goto and his associates usually worked on a small scale,

but they produced many beautiful paintings that captured the spirit of those particular times. Interestingly enough, from the viewpoint of cultural history, the Seiko Society also had close affiliations with the *Shirakaba* group.

RESPONSES TO THE SOCIAL MILIEU As outlined above, one of the main features of art between 1925 and 1940 was the culmination of movements that had begun in Meiji and continued through Taisho. The other main feature was the budding of new artistic styles after the Great Earthquake of 1923.

We have already noted that in the aftermath of the earthquake there appeared on the one hand a movement toward so-called proletarian art and on the other a wave of enthusiasm for futurism, dadaism, and surrealism. For a time there was a period

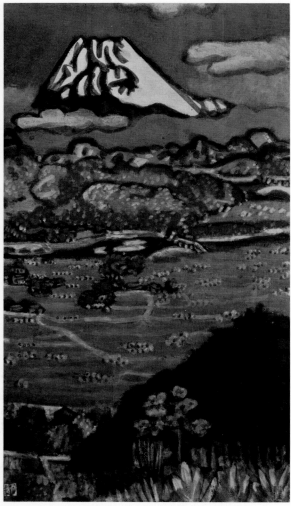

118. *Umehara Ryuzaburo:* The Supreme Excellence of Nature. *Oil on canvas; height, 112.7 cm.; width, 62.7 cm. 1952.*

of more or less destructive confusion, but out of this there gradually emerged the new directions that art was to follow in succeeding decades.

There appeared, for example, a new social consciousness, one manifestation of which was the so-called proletarian art. This tended to concern itself with themes having to do with the labor movement, which were treated in a rather conceptual version of the socialist-realist style. The paintings were usually simplistic, and the technical level of the artists was low. Moreover, as fascist attitudes spread during the thirties, the "proletarians" found themselves the victims of thought control, and their movement subsided into a mere undercurrent before it had had a chance to achieve significance.

A different response to the social stimuli of the times is evident in the works of the *nihonga* artists of the Seiryusha (Blue Dragon Society), who, unlike the "proletarians," did not aim at enlightening and educating the masses but put more emphasis on popular appeal than on individual expression. The leader of this group was Kawabata Ryushi (1885–1966; Fig. 108), who felt that the neoclassicism of the Japan Art Academy was too aristocratic and confining. Kawabata argued in favor of "healthy exhibition art" that would appeal to people in general. It was an age in which there was a growing rift between "pure literature" and "popular literature," and the secession of the Seiryusha from the academy represented a similar development in the field of painting.

NEW EXPLORATIONS IN PURE ART

A number of the more individualistic artists, while keeping an eye on the social aspects of their work, sought new effects in the realm of pure art. There was a surrealist movement as well as an attempt at a purer version of fauvism, and just about everything new that turned up at the École de Paris found at least a few young Japanese champions.

An early milestone in the development of this more contemporary art was the formation in 1926 of a group that called itself the 1930 Association (1930-nen Kyokai). The first participants in this group were Kojima Zentaro (1892–), Satomi Ka-

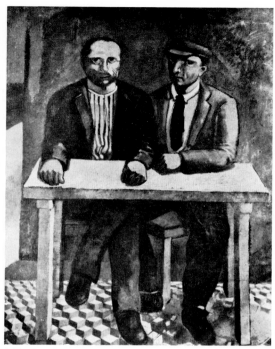

119. *Maeda Kanji:* Two Laborers. *Oil on canvas; height, 144 cm.; width, 112 cm. 1923. Ohara Art Museum, Kurashiki, Okayama Prefecture.*

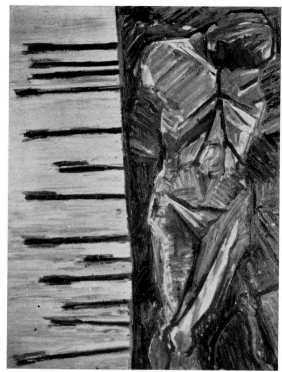

120. *Ebihara Kinosuke:* Martyr. *Oil on canvas; height, 100 cm.; width, 72.5 cm. 1953. Tokyo National Museum of Modern Art.*

tsuzo (1895–; Fig. 122), Maeda Kanji (1896–1930; Fig. 119), Saeki Yuzo (1898–1928; Fig. 116), and Kinoshita Takanori (1894–1973). These five were later joined by Hayashi Takeshi (1896–), Noguchi Yataro (1899–), and Kawaguchi Kigai (1892–1966). All of these men had been promising young artists in the government exhibitions, the Nika Society, or the Shun'yo Society, and a number of them achieved considerable prominence in the postwar period. At the time when the 1930 Association was organized, the two leaders were Saeki, who had acquired his passionate fauvism in the back streets of Paris, and Maeda Kanji, who leaned toward realistic portrayals of nudes, laborers, and the society he saw around himself. Special mention should perhaps be made of Satomi Katsuzo, whose fresh,

disingenuous coloring and touch astonished art circles of the late twenties.

As it happened, the 1930 Association disbanded in the very year 1930, and most of its members joined Kojima Zenzaburo (1893–1962; Fig. 124), Ito Ren (1898–), Takabatake Tatsushiro (1895–), Fukuzawa Ichiro (1893–; Fig. 125), and Migishi Kotaro (1902–34; Fig. 126) in forming the Independent Art Association (Dokuritsu Bijutsu Kyokai), which held its first exhibition in 1931. Afire with the purpose of creating and conquering new worlds with their new images, these artists were destined to become the link between the Yasui-Umehara period and the postwar age. The group was later joined by Kobayashi Wasaku (1888–), Ebihara Kinosuke (1904–70; Fig. 120), and Suda

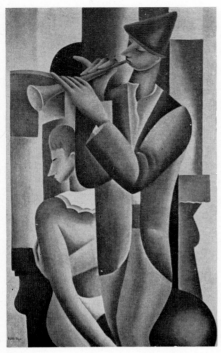

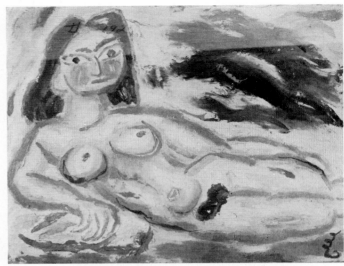

122. *Satomi Katsuzo:* Nude. *Oil on canvas; height, 72.5 cm.; width, 90 cm. 1927.*

121. *Togo Seiji:* Saltimbanques. *Oil on canvas; height, 114 cm.; width, 71 cm. 1926. Tokyo National Museum of Modern Art.*

Kunitaro, the last of whom, as we have noted, was unusual in that his European experience was acquired mostly in Spain rather than in France. With his deep understanding of Eastern and Western art traditions, Suda was a bright star in postwar Japanese art until his death in 1961.

Among the artists who became active in the Nika Society and other groups during the late twenties and early thirties were several who incorporated elements of futurism, cubism, and surrealism, and a new art of the fantastic came into being with their works. Early leaders of this avant-garde were Togo Seiji (1897–; Fig. 121), Koga Harue (1895–1933; Figs. 36, 123), and Kawaguchi Kigai. As time went on, features of abstract art were added by painters like Yamaguchi Takeo (1902–), Yoshiwara Jiro (1905–72), Saito Yoshishige (1904–), and other members of the Room Nine Society (Kyushitsukai). In 1939 some members of this group joined

with Fukuzawa Ichiro, a painter influenced both by fauvism and by the surrealism of Max Ernst, to form the Art Culture Association (Bijutsu Bunka Kyokai). Other important members of this new association were Kitawaki Noboru (1901–51; Fig. 127), Ai Mitsu (1907–46; Fig. 41), and Aso Saburo (1913–).

By this time the war had already begun in China, and members of the new group were unable to produce many works of significance, but the group served as a sort of nucleus for artists who belonged to one branch or another of the avant-garde. Another advanced group, called the Free Art Association (Jiyu Bijutsu Kyokai), was organized at this time by Hasegawa Saburo (1906–57; Fig. 136), Murai Masanari (1905–), Yamaguchi Kaoru (1907–68), and others, but for the most part these artists did not achieve prominence until the postwar period, when the new democratic spirit engendered in

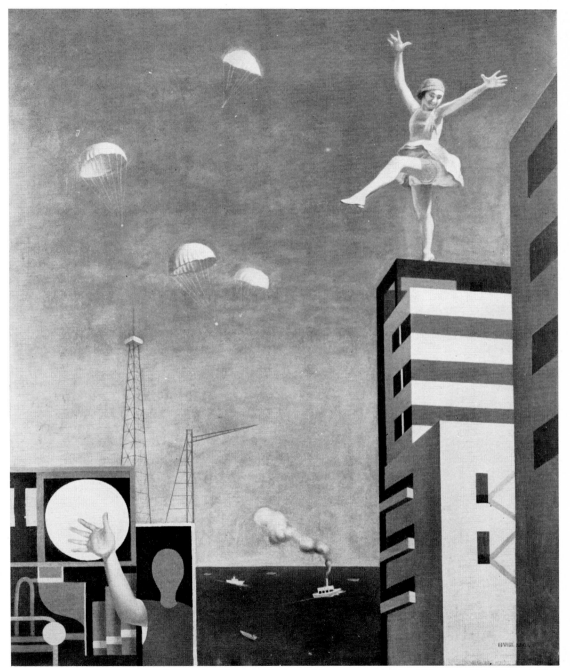

123. *Koga Harue:* The Scene Outside the Window. *Oil on canvas; height, 161 cm.; width, 129 cm. 1930.*

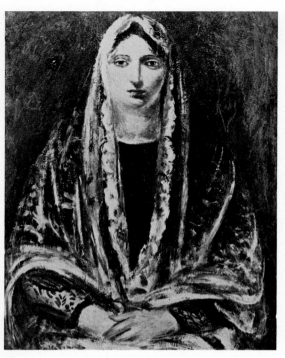

124. *Kojima Zenzaburo:* Portrait of a Western Lady. *Oil on canvas; height, 80.3 cm.; width, 65 cm. 1928.*

125. *Fukuzawa Ichiro:* Science Blinds ▷ Beauty. *Oil on canvas; height, 162 cm.; width, 112 cm. 1930.*

Japan by the occupation removed the restraints from avant-garde art and started literally dozens of new movements in various fields of modern painting.

MODERN HANDICRAFTS AND ARCHITECTURE

No history of modern Japanese art would be complete without at least a brief mention of new developments in the crafts and in architecture.

In general, the handicrafts are so closely connected with daily life that they have a built-in conservatism. At the beginning of Meiji, traditional Japanese handicrafts of Edo-period style met with considerable favor at the Vienna International Exposition in 1873, and afterward there was wide support among the Japanese upper classes for the maintenance of art crafts that had been handed down from the past. There were even attempts at incorporating new methods from the West, but throughout Meiji and Taisho the emphasis was on the aristocratic tradition, which actually was only one of several traditions that existed. The same aristocratic tradition dominated the handicrafts section at the government exhibitions. Despite certain efforts to apply Japanese methods to objects of Western origin, it cannot be said that there was any great innovation or notable originality in the crafts until the 1920s, when the folk-art movement led by Yanagi Soetsu (1889–1961) began to gather momentum. Yanagi was extremely enthusiastic about the beauty to be found in the craft objects that had long been in use by the Japanese lower classes, and he developed a whole theory of folk art that became a kind of philosophy, if not a religion, for his followers and admirers. By the 1930s these people were fairly numerous, and a number of professionals had begun to work in styles inspired

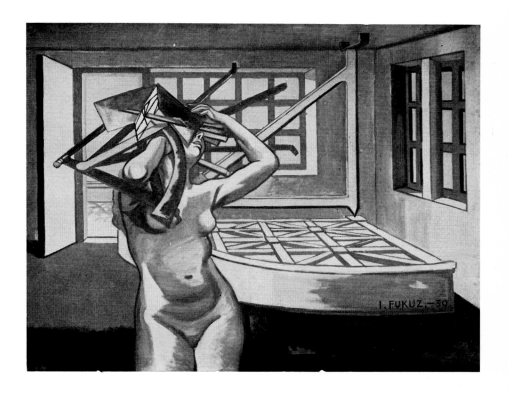

by folk arts. Among them were the now famous potters Kawai Kanjiro (1890–1960; Fig. 86), Tomimoto Kenkichi (1886–1963; Fig. 87), and Hamada Shoji (1894–; Fig. 89) as well as the expert dyer Serizawa Keisuke (1895–). Craftsmen of this school usually exhibited in the crafts section of the Kokugakai (National Art Society), and their works were, on the whole, of higher quality than those shown at the government exhibitions.

This strong new movement in the crafts brought a new enlightenment to the world of art as a whole, and many artists came to recognize that there existed a beauty in the objects used in ordinary everyday life. Indeed, one could find in such folk art a strength, a balance, and a richness that could hardly be hoped for in the comparatively rootless art that had been transplanted from abroad. The pursuit of this new kind of beauty was given expression, for example, in the woodblock prints produced by

Munakata Shiko (1905–; Fig. 88) and a number of other artists encouraged and supported by Yanagi Soetsu. Thanks to the folk-art movement, many people came to feel that it was in the unsophisticated folk arts and crafts that the true tradition of the Japanese people had been preserved, and in postwar years these arts and crafts have attracted many admirers in other countries.

In the past three or four decades there have also been a considerable number of potters who, while not actually belonging to the folk-art movement, have tried to breathe new life into the classical tradition. Among them was the late Kitaoji Rosanjin (1883–1959; Fig. 90). These artists, together with those already mentioned, have given a great stimulus to the world of crafts in Europe and America. It is clear that in the Japanese crafts, whether classical or in the folk-art vein, there is a very real, pulsating tradition that cannot be found in the

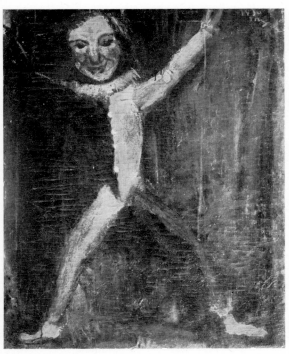

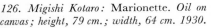

126. *Migishi Kotaro:* Marionette. *Oil on canvas; height, 79 cm.; width, 64 cm. 1930.*

127. *Kitawaki Noboru:* Self-Portrait. *Oil* ▷
on canvas; height, 80.5 cm.; width, 117 cm.
1946. Tokyo National Museum of Modern
Art.

fields of painting and sculpture in modern times.

Whereas the crafts are rooted in the traditions of the Japanese way of life, from which they have spread outward, in the case of architecture the movement has in a sense been the reverse, for the problem here has been to adapt Western techniques and building methods to Japanese ways of life as well as to the Japanese concept of beauty. From the time of its establishment the Meiji government actively encouraged the importation of Western architecture, and nearly all of the public buildings for which it was responsible were in Western style. Meiji and Taisho were eras of simple importation, and the fact that Western architecture was still definitely foreign to the Japanese of those times is amply clear from the wide gap between public architecture and the houses in which people lived. It is only in the past five decades, and particularly

in the last three, that this gap has started to close. Broadly speaking, architecture in the past century started with a period in which Japanese and Western buildings existed side by side, continued through a period of eclecticism, and has now arrived at a state of fusion and amalgamation made possible by a revolution in building materials and techniques.

It cannot be said even today that the gap between public and private architecture has been fully spanned or that harmony has been achieved between foreign forms and traditional ways of life. Indeed, contemporary Japanese architecture has not advanced very far beyond the stage in which everything that was old was being denied and destroyed. Still, one can see potentialities for a new and harmonious amalgamation of the traditional and the new. A comparison of the so-called Foreigner's House in Kobe (Fig. 128) and the Tomioka

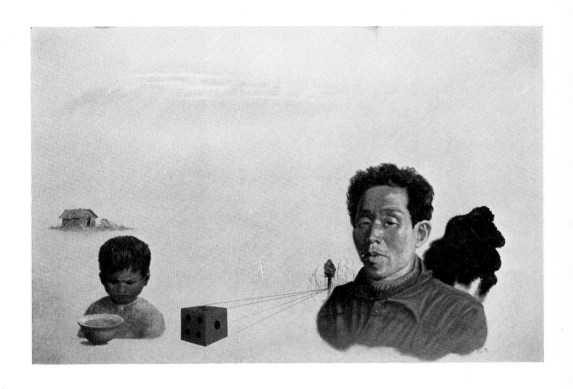

Silk Plant in Gumma Prefecture (Fig. 129) with the postwar Tokyo Festival Hall (Fig. 133) and the Kagawa Prefectural Office (Figs. 134, 135) clearly shows that contemporary architects have advanced beyond the stage of believing that modernization is identical with Westernization. A significant landmark in this development was Frank Lloyd Wright's Imperial Hotel in Tokyo (Figs. 10, 140).

Modern Japanese craftsmen, drawing on the spiritual tradition of Japanese life, have in many ways realized that the process of becoming contemporary is the process of becoming artists of the world. Conversely, modern Japanese architects have reached the stage at which they are attempting to use the newest and best techniques from all over the world to create an environment in which Japanese can live in spiritual peace and comfort. In a way, the universality that has been achieved in these fields on the periphery of art is a challenge to the center.

There is a definite link between architecture and the crafts on the one hand and the Occidentalist and Reformist traditions mentioned at the beginning of this book. By analogy, one might say that modern Japanese art as a whole has swung like a pendulum between the approach of the architects and that of the craftsmen. Herein we see the fundamental reason for the persistence even in our own times of a verbal and organizational distinction between Western-style painting and *nihonga*—a distinction that would be unthinkable in America or Europe. The problem of the future is to go back to the original source of this ambivalence. When this has been accomplished, the period of the three fundamental types that we have outlined will have come to an end.

CHAPTER SIX

The Lineage of
Modern Japanese Art

THIS CHAPTER, dealing chiefly with Japanese art schools and organizations, presents a summary of developments in *nihonga, yoga,* sculpture, and architecture from the beginning of the modern age in 1868 up to recent years. The author acknowledges his indebtedness to the noted architectural critic Kojiro Yuichiro for supplying the section on architecture.

NIHONGA In the early years of Meiji there were two main divisions in the field of *nihonga,* one centering in Kyoto and the other in Tokyo. Let us look first at the developments in Kyoto.

During the closing years of the Edo period, the artists of Kyoto held an integrated exhibition in which the various schools of painting in that city were represented. This event, known as the Higashiyama Shunju Tenkan, led to the establishment of the Jounsha, a society centered mainly around artists of the Maruyama-Shijo lineage. The Jounsha continued into the Meiji age. Even in the last years of the Edo period, then, there already existed an organized society of painters, and since this group had connections with such traditional crafts of Kyoto as ceramics, dyeing, and weaving, it was not shaken by the political and social changes that marked the advent of the Meiji era. Handed down

intact, it served as the foundation for the establishment of the first modern academy of painting in Japan: the Kyoto Prefectural Painting School. This school eventually became the Kyoto Municipal College of Arts, which today exerts a major influence on Kyoto's painting circles. Leading artists of the modern Kyoto school emerged from the institution in the course of its history, and, as far as *nihonga* is concerned, the level of achievement was higher than that reached in the government-operated art schools of Tokyo.

The Jounsha was succeeded by the Koso Kyokai, but as the influence of the other painting schools expanded, this organization gradually lost its meaning. Having concentrated on exhibitions by Kyoto artists alone, it faded away after the initiation of the nationwide Bunten, or Ministry of Education Exhibition.

The *nanga* artists also banded together, and although the *nanga* lost popularity in the Meiji era, such organizations as the Japan Nanga Association were formed. Tomioka Tessai and others joined forces with this association, but after the advent of the Bunten and the Teiten (the Imperial Art Academy Exhibition), it declined to the status of an ordinary artists' group. After having formed the now defunct Japan Nanga Academy in the Taisho era, the *nanga* artists' group went on to survive the

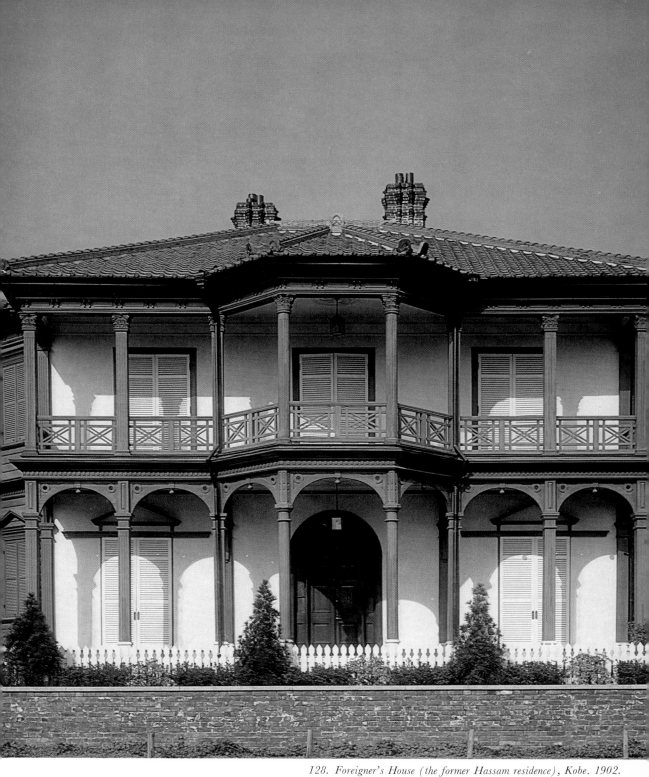

128. Foreigner's House (the former Hassam residence), Kobe. 1902.

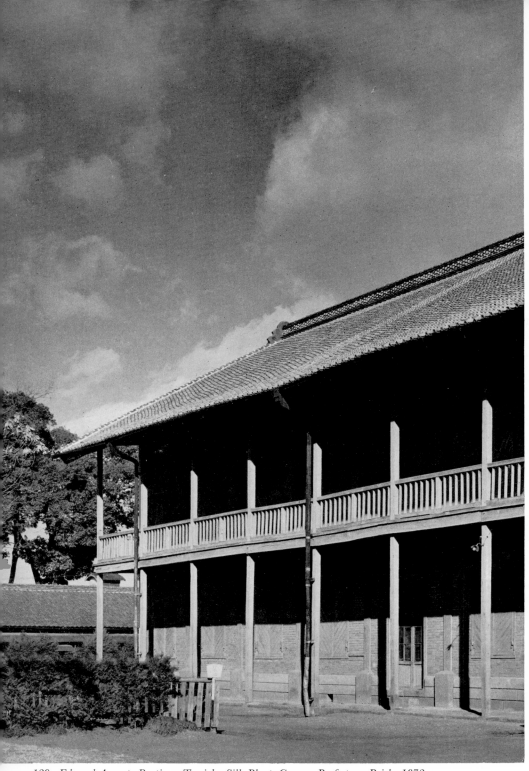

129. *Edmond Auguste Bastien: Tomioka Silk Plant, Gumma Prefecture. Brick. 1872.*

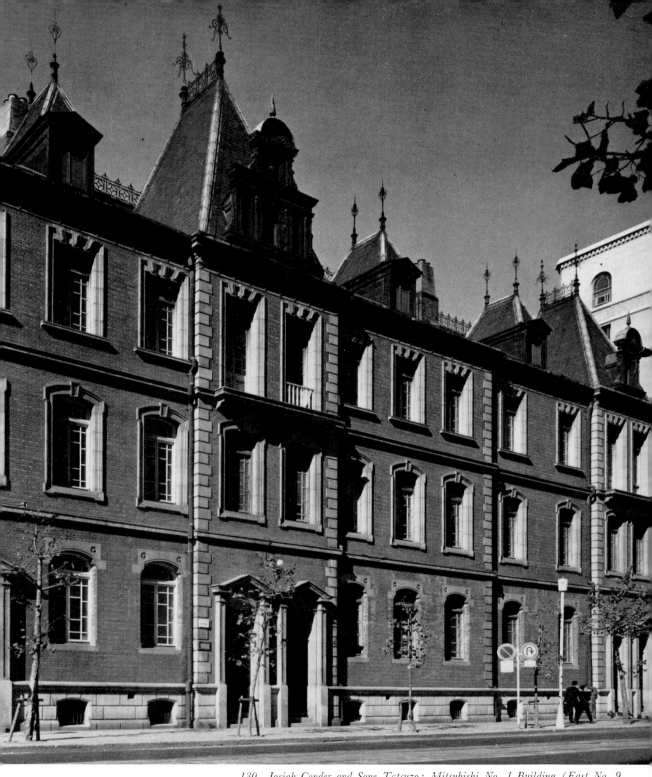

130. Josiah Conder and Sone Tatsuzo: Mitsubishi No. 1 Building (East No. 9 Building), Tokyo. Brick. 1894. (See also Figure 139.)

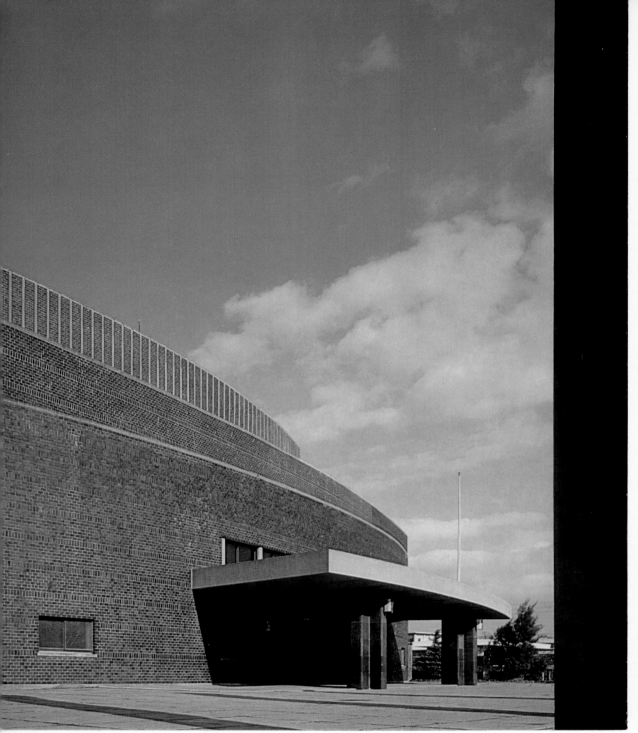

131. *Murano Togo: Ube Citizens' Hall, Yamaguchi Prefecture. 1937.*

132. *Yamada Mamoru: Ministry of Communications Hospital, Tokyo. 1937.* ▷

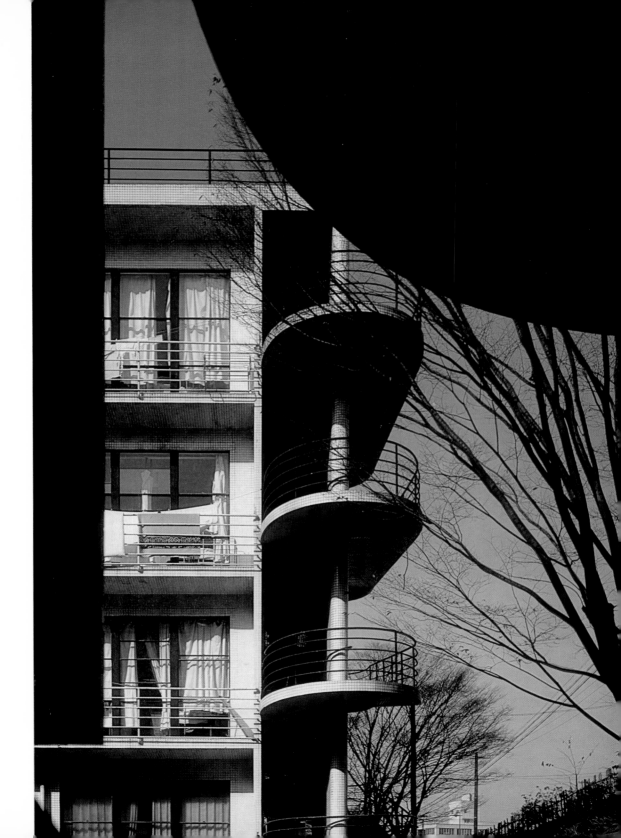

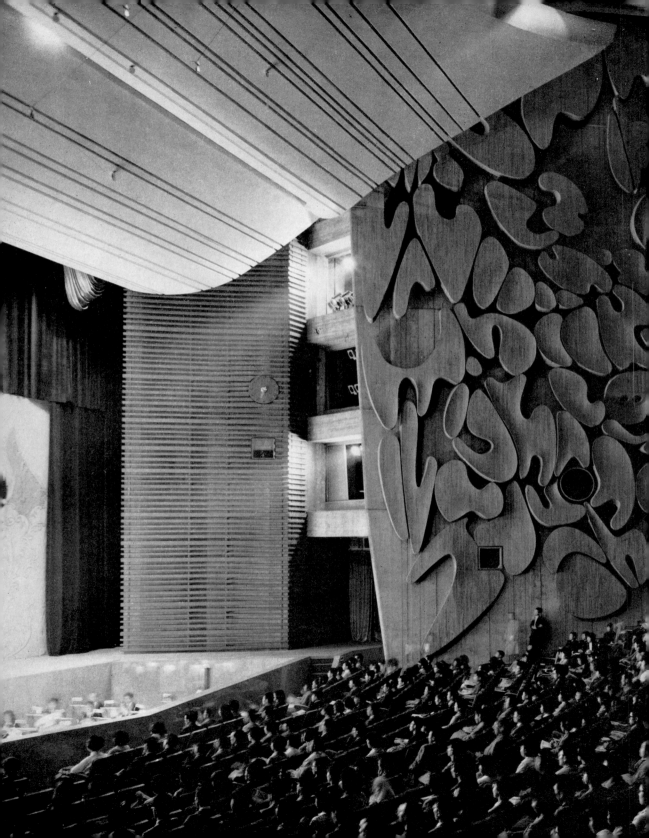

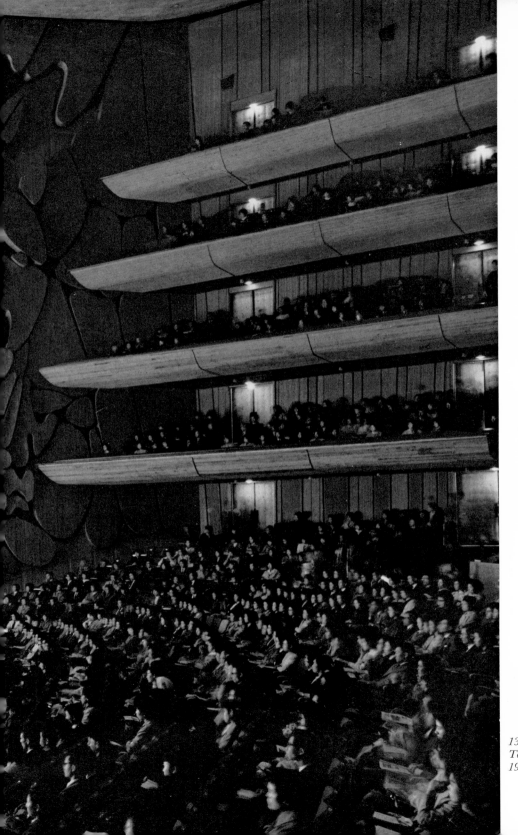

133. Maekawa Kunio:
Tokyo Festival Hall.
1961.

134 (opposite), 135. Tange Kenzo: Kagawa Prefectural Office, Takamatsu. 1958.

war years and to continue into the postwar period, but it has had a rather on-and-off existence.

Thus there was a general tendency for most of the Kyoto artists' groups to be absorbed into the Bunten and the Teiten. In the Taisho era, however, Tsuchida Bakusen and other influential artists broke away from the government-sponsored exhibitions, formed the Kokuga Sosaku Kyokai (National Painting Creation Association), and thereby gave a major stimulus to the whole modern *nihonga* world. Although most of the offshoots of this association later returned to the government exhibitions, after World War II a group of leading artists centering around Uemura Shoko participated in forming the society Sozo Bijutsu (Creative Art). Today the Kyoto school contributes a considerable number of talented painters to the *nihonga* section of the Shin Seisaku Kyokai (New Creation Association).

In contrast with the *nihonga* circles of Kyoto, which evolved directly out of Edo-period schools, those of Tokyo were greatly influenced by the changes that attended the Meiji Restoration, and for this reason they had to make a new beginning. The first major move was made by the Ryuchikai (Dragon Pond Society), which was established with the aim of resurrecting and preserving the characteristically Japanese painting schools dating from Edo times. This lineage was continued by the so-called old-school artists of the Japan Art Association, which in Meiji times received substantial support from the imperial court and the aristocracy. For some time after 1890, when the system of awarding imperial honors to artists was begun, such honors went mainly to members of the association. During the Bunten and Teiten years, however, these artists found themselves much in conflict with the so-called new-school artists. They gradu-

136. Hasegawa Saburo: Butterfly Tracks. Oil on canvas; height, 127 cm.; width, 160 cm. 1938.

ally lost their prestige, and what little remained of their influence almost completely disappeared with the beginning of World War II. The postwar Japan Art Association formally continues the lineage of its prewar predecessor, but it has been thoroughly reorganized, and today it has as its axis the new-school tradition dating from Meiji and Taisho.

In opposition to the conservative, old-school tendency of the Ryuchikai, the Kangakai (Painting Appreciation Society) of Fenollosa, Kano Hogai, and Hashimoto Gaho took a progressive, new-school stance. As the ideas of the Kangakai developed, they were adopted as the educational policy of the Tokyo Art School and further advanced by its first principal, Okakura Tenshin, in the direction of a new, magnificent *nihonga* imbued with Asian romanticism. Yokoyama Taikan, Shimo-

mura Kanzan, and Hishida Shunso were representative graduates of this school. These three artists, together with Terasaki Kogyo and Kajita Nanko (members of the Japan Youth Painting Association), organized the Japan Painting Association. Shortly thereafter, this group joined hands with Hashimoto Gaho and Okakura Tenshin (who had resigned as principal of the Tokyo Art School) to establish the Japan Art Academy. When the Bunten was instituted, the academy participated in it, but the existing dispute between the old-school line of the Japan Art Association and the new-school line of the academy was aggravated. The struggle turned to the advantage of the new-school forces, but the academy, of which a number of new-school artists were members, was nevertheless forced out of the Bunten. Since the resurrection of

137. *Koiso Ryohei:* Composition with Human Figures. *Oil on canvas; height, 91 cm.; width, 72.7 cm. 1952.*

138. *Fukuda Heihachiro:* Rain. *Colors on paper; height, 108.5 cm.; width, 86.5 cm. 1953.*

the academy through the efforts of Tenshin's followers in the early Taisho era, it has sponsored its own exhibition, the Inten, always outside the official patronage of the government. The restored academy, following its own nonofficial and independent path and expressing itself through the Inten, which has continued to this day, has displayed its authority and maintained its function as the principal axis of the *nihonga* world in Taisho and Showa times. We can attribute this achievement to its origins in the Meiji era, just as we can recognize in the figure of Yokoyama Taikan its central driving force.

In addition to these developments during the Meiji and Taisho eras, we may note the establishment of several new organizations in the Showa era. The Inten produced two offshoots: the Blue Dragon Society (Seiryusha) and the New Art Academy (Shinko Bijutsuin). The Blue Dragon Society departed from the neoclassicist line of the Inten and aimed at the creation of what it called "wholesome exhibition art for the people," for which purpose Kawabata Ryushi began the practice of producing large-scale paintings. The New Art Academy, composed of *nanga* painters who seceded from the Inten, chiefly pursued the course of creating a new and vigorous type of *nanga*. Other groups that have worked for new forms of *nihonga* in the Showa era are the New Artists' Association (Shin Bijutsuin Kyokai) and the Rekitei Bijutsu Kyokai. The New Artists' Association in turn gave rise to the society known as Creative Art (Sozo Bijutsu) and the *nihonga* section of the New Creation Association (Shin Seisaku Kyokai) of the post-

139. Josiah Conder and Sone Tatsuzo: Mitsubishi No. 1 Building (East No. 9 Building), Tokyo. Brick. 1894. (See also Figure 130.)

war period. The Nihongakai (Nihonga Society), a group that branched off from the old school in the Meiji era, went through several evolutionary stages until the Showa era, when it became the Nihongain (Nihonga Academy), modifying its line in an effort to approach the government exhibitions.

YOGA The lineage of *yoga* in modern Japan begins with the private painting schools established during the influx of Western ideas in the early Meiji era. Among such schools were the Goseda Juku of Goseda Yoshimatsu, the Choko Dokugakan of Kawakami Togai, and the Tenkaisha of Takahashi Yuichi. When an art school was established as a branch of the Technological College, the students in these private schools were offered the opportunity of study under Fontanesi, and after he returned to Italy, the first *yoga* circle, called the Juichikai (Eleven Society) was formed. The study group attached to the society later be-

came the Fudosha, which fostered a number of young *yoga* artists during the first half of Meiji. The various new classes and study groups were joined by the students of Kawamura Kiyo-o, Harada Naojiro, Yamamoto Hosui, and other teachers who had studied in Europe. In 1889, with the formation of the Meiji Bijutsukai (Meiji Art Society), an amalgamation of all *yoga* circles was accomplished for the first time. The Meiji Bijutsukai was later reconstituted as the Pacific Painting Society, and its successor, the Pacific Art Society, is still active.

In opposition to this old school, or "resin school," as it was called, the artists who gathered around the Tenshin Seminar of Kuroda Seiki formed the White Horse Society, which came to be known as the new school or the "purple school." This group initiated a shift from plein-airism to impressionism and thus became the mainstream of Japanese *yoga* circles. In its exhibitions of *yoga* the Bunten maintained an equilibrium between the Pacific Painting Society

140. Frank Lloyd Wright:
Imperial Hotel, Tokyo.
1922. Demolished in 1968.
(See also Figure 10.)

and the White Horse Society, but since members of the latter monopolized the teaching positions at the government school itself—the Tokyo Art School—its power was always predominant. The White Horse Society disbanded during the last years of Meiji, but its successor, the Kofukai, continues to be active today.

In the Meiji era, Japanese *yoga* circles were more or less unified by the Bunten, but from the Taisho era on, influential antiofficial groups mushroomed one after another. Artists began to insist upon such matters as the authority of subjectivity and respect for individuality; new styles like postimpressionism and fauvism were adopted; and rapid changes took place in the art world. This tide of developments brought into existence the Fusain Society, the Sodosha, and the *yoga* section of the Japan Art Academy—three organizations that were to be amalgamated into the Shun'yokai. In Kyoto, a *yoga* section was established in the Kokuga Sosaku Kyokai and,

under the leadership of Umehara Ryuzaburo, later emerged as the Kokugakai, or National Painting Society. Both the Shun'yokai and the Kokugakai are still influential today.

It was the Nika (Second Division) Society, however, that became the leading power among the antiofficial groups. Its name derives from the circumstances in which it was born. A number of progressive artists of the Bunten maintained that a second division should be established in the *yoga* section, just as in the *nihonga* section, to accommodate artists who worked in new styles. This proposal was rejected by the authorities of the Bunten, whereupon the dissident artists declared their independence and formed their own second division—that is, the Nikakai, or Nika Society. The members of this group continuously introduced new styles from Europe and furnished a vital stimulus to the *yoga* circles of the Taisho and Showa eras. They also performed the meritorious service of

141. *Aerial view of elevated expressways in downtown Tokyo completed in 1964.*

fostering a number of young and able artists. In response to the stimulus they offered, many small avant-garde groups were born during late Taisho. As more changes took place in the art world, new movements were initiated by the 1930 Association and the Independent Artists' Association.

When the Imperial Art Academy was reorganized in 1935, some of the founders of the Nika Society were selected as academy members. These artists then formed the Issuikai, while the Nika Society continued without them. After the war, some members of the Nika Society branched out and formed the Kodo Bijutsu Kyokai, the Dainikikai, and the Ichiyokai.

The years after 1935 saw rising young artists of the government exhibition leaving it to form the Shin Seisakuha Kyokai (New Creation Association), other young artists with new styles organizing the

Jiyu Bijutsuka Kyokai (Free Artists' Association), and surrealist members of the Independent Artists' Association starting the Bijutsu Bunka Kyokai (Art and Culture Association). In fact, it was in the late 1930s that the postwar inundation of artists' organizations had its beginning. This tendency of art groups to proliferate existed among government-exhibition artists as well, for the Teiten produced such offshoots as the Tokokai, the Ogenkai, the Sogenkai, and many others. Today the increase in the number of art groups has reached the point where the differences among them are hardly distinguishable, and works of similar tendencies are shown under different labels.

SCULPTURE In the closing years of the Edo period, traditional techniques of sculpture were preserved only by carvers of Bud-

dhist images; carvers of decorations for palaces, temples, and shrines; carvers of the miniature sculptures known as *netsuke;* and makers of dolls for the Doll Festival—all occupations more properly classified as crafts than as sculpture. A succession of organizations ranging from the above-noted Ryuchikai to the Tokyo Sculptors' Association undertook to restore and improve the techniques of these crafts, partly with an eye to the export trade. These organizations declined as time went on, but one of their successors, the department of wood sculpture at the Tokyo Art School, continued their efforts, progressing on the one hand toward realism and, on the other, aiming at the restoration of the techniques of classical Buddhist sculpture. Here Takamura Koun and Takeuchi Kyuichi (1857–1916) were the central figures in the establishment of the lineage of modern Japanese

sculpture in wood. Niiro Chunosuke (1868–1954), a member of the Nara branch of the Japan Art Academy and a specialist in repairing Buddhist images of earlier times, was of this lineage, as were also Yamazaki Choun (1867–1954), Hiragushi Denchu (1872–), and Yonehara Unkai (1869–1925)—all members of the Japan Sculpture Society. These artists, however, later divided into pro-Bunten and pro-Inten factions.

The Western-style modeled sculpture taught by Ragusa at the art school of the Technological College was handed down through the Meiji Art Society and the White Horse Society and was at length transmitted by Fujita Bunzo (1861–1934) to the department of modeled sculpture at the Tokyo Art School. More significant contributions in this field of sculpture were made by such artists of the second period as Naganuma Moriyoshi (1857–

142. *Isamu Noguchi: bridge in Hiroshima. 1952.*

1942) and Shinkai Taketaro, both of whom had studied in Europe. Naganuma exerted his influence on the Meiji Art Society and the Tokyo Art School; Shinkai, on the research institute of the Pacific Painting Society and on the Bunten. Both were important figures in the development of late-Meiji sculpture in Western style.

Thus the sculpture exhibited at the Bunten was of two lineages: wooden sculpture in the native tradition and modeled sculpture in Western style. From the last years of Meiji the influence of Rodin began to appear in the works of Ogiwara Morie and Takamura Kotaro, and this new wave carried with it the young artists of the Inten. Fujikawa Yuzo of the Nika Society became known for introducing new styles of sculpture that developed in Europe after Rodin.

In the Showa-era world of sculpture there were three divisions. The first of these comprised the wide range of groups associated with the official exhibitions, including the Kozosha, which was of Western-style lineage, and the Japan Wood Sculpture Society. The second division consisted of groups influenced by the antiofficial Inten, while the Nika Society represented the third. The sculpture section of the Kokugakai, initiated during Showa, introduced such new styles as that of Bourdelle. The movement thus begun has been transmitted to the Shin Seisakuha Kyokai and has had a greater development in postwar Japan.

All the groups that split off from the Nika Society after the war—groups like the Free Artists' Association—have their own sculpture sections, and abstract sculpture is spreading among them. It is also noteworthy that the two streams flowing from the Meiji era—those of wood sculpture and modeled

sculpture—have approached each other in recent years.

ARCHITECTURE In the Meiji era the only institution that offered training to future architects was the department of architecture at the Technological College. This department, which was the predecessor of the present department of architecture at the University of Tokyo, taught Western-style architecture. As can be seen from the style of Josiah Conder (1852–1920; Figs. 130, 139), the first of its instructors, its goal was to design buildings that effectively combined a number of European styles of the past. For this reason the Japanese architectural academy, comprising the graduates of Conder's course, was for a long time characterized by eclecticism.

In 1920, stimulated by the modern architectural movements of Europe and aided by the industrial development of Japan, a group of architects rebelled against academic eclecticism and formed the Bunriha Kenchikukai (Secessionist Architectural Society). The designation "secessionist" indicated the group's basic attitude of turning away from conventional styles and creating new kinds of architecture.

In 1925, architects influenced by Walter Gropius's idea of "international architecture" inaugurated the Japan International Architectural Society in western Japan. Kawakita Renshichiro, following the functionalist indoctrination of the Bauhaus, started the New Architectural and Crafts Institute, which was joined by Mizutani Takehiko, a former student at the Bauhaus. The noted designers Kamekura Yusaku and Kuwazawa Yoko are graduates of this institute.

All these new moves were more or less unified in the prewar organization known as the Japan League of Constructional Culture. The lineage from the Secessionists to the league represents the sequence of cultural and artistic movements in modern Japanese architecture.

Such essentially stylistic movements can be compared with others that displayed stronger social consciousness and aimed at modernizing and rationalizing the systems and processes of architectural production. Whereas the leaders of the former were chiefly university graduates, those of the latter were for the most part graduates of higher industrial schools. The Sousha, established in 1923, had an artistic coloring because some of its members came from the Secessionist Architectural Society. This group later changed its name to the New Architects' League and then to the League of Young Architects of Japan. Eventually, however, it collapsed under the increasing weight of government oppression.

The artistic and the social movements in modern Japanese architecture, faced with the postwar reconstruction of Japan, were unified into the New Japan Architectural Group. But when actual construction works were activated by the Korean War, they both died out. Perhaps it was no longer the age of movements.

Along with the artistic movement in modern architecture there was a movement toward alliance with the other arts. When the Kokumin Bijutsu Kyokai (National Art Association), under the presidency of the architect Chujo Seiichiro, held the Capital City Restoration Exhibition in 1924, soon after the Great Kanto Earthquake, almost every group—the Secessionists, the Sousha, the Rato, the Meteor, the Mavo, and the Sanka (Third Division)—participated in it. After this, however, art was not generally welcomed in architecture, and there was no unification of groups until the postwar establishment of the architectural section of the Shin Seisaku Kyokai.

CHAPTER SEVEN

Local Art Museums

PROTOTYPES OF ART MUSEUMS Today Japan has many museums, including a number of interesting specialized or local museums set up since the war, but the country was considerably behind Europe and America in developing institutions of this sort. The main reason for the delay was that the modern concept of art, like most other modern ideas, was introduced to the country from the top political and social level in Tokyo and required time to filter down and spread to the people as a whole.

If, however, the establishment of art museums in the modern sense was delayed, prototypes of such institutions had long been in existence. Just as in the West, where the collections of royalty, the aristocracy, and rich families served as a starting point, in Japan too the collections of Buddhist temples, Shinto shrines, and the daimyo came in time to serve as foundations for museums of the modern age. Unfortunately, since many of the treasures in these collections were scattered or lost in the upheaval that accompanied the Meiji Restoration, it was rarely possible simply to transform an existing collection into a museum. In 1871, however, soon after the inauguration of the Meiji government, the cabinet issued an ordinance calling for the preservation of traditional art objects and thereby initiated a policy that led first to the establishment of state museums—the Tokyo National Museum in that same year and then, in mid-Meiji, the national museums of Nara and Kyoto. For some time these

three were known as imperial museums and functioned as treasuries for the art objects owned by the imperial household. The museums in Nara and Kyoto also served for the exhibition of treasures borrowed from the many temples and shrines in the Kansai region—that is, the region embracing Nara, Kyoto, and Osaka.

The movement thus initiated by the government was further advanced when a number of leading temples and shrines throughout the country began to display their art treasures and historical materials to the public on their own premises. Although these institutions had not yet adopted the practice of erecting independent buildings to serve specifically as art galleries—the treasure halls and memorial halls of today—the predecessors of such buildings had been functioning since the middle years of Meiji.

THE ADVENT OF THE PRIVATE COLLECTOR In contrast with the art galleries eventually set up by temples and shrines, we have the new type of privately owned museum established by influential collectors and men of wealth. Whereas the treasures owned by religious institutions usually remained in their original locations, those that survived from the collections of the daimyo and the nobility almost all came under new ownership after the beginning of Meiji, and along with the development of capitalism in Japan, a new class of affluent collectors

143. Ohara Art Museum, Kurashiki, Okayama Prefecture. Opened in 1930.

appeared on the scene. At the same time that these new collectors gathered together Japanese art objects from earlier times, they added recent imports from abroad and thus gradually built up collections of unprecedented quality and size. Although there were noteworthy collectors like Matsukata Kojiro and Hara Sankei who did not provide facilities for the public display of their collections, others built their own museums. From the last years of Taisho through the early years of Showa, privately owned museums were established here and there throughout Japan.

The principal museums of this type are the Okura Shukokan in Tokyo, founded in 1917, the Fujii Museum in Osaka (1926), the Ohara Art Museum in Kurashiki (1930; Fig. 143), the Hakutsuru Art Museum in Kobe (1931), the Tokugawa Art Museum in Nagoya (1931), the Japan Folk Crafts Museum in Tokyo (1936), the Tenri Museum in Nara Prefecture (1938), the Ikenaga Art Museum (presently the Kobe City Museum of Namban Art) in Kobe (1940), and the Nezu Art Museum in Tokyo (1940).

The collections in most of these museums are made up largely of antique Oriental art, since they derive from the collections of daimyo and of old temples and shrines, but they have been expanded to suit the modern age. The Ohara Art Museum is given over mainly to Western art and was the first of its kind in Japan. The Japan Folk Crafts Museum and the Kobe City Museum of Namban Art deserve mention as special cases in that the former houses a collection of traditional folk art and the latter a collection of *namban* art: the European-inspired Japanese art of the late sixteenth and early seventeenth centuries.

PREWAR ART
MUSEUMS
There were three basic types of Japanese art museums in prewar times: first, museums established by old temples and shrines; second, museums established by men of wealth and influence for the display of their own collections; and third, public museums of modern art in which space was frequently rented for exhibitions by various groups.

Although the collections of the museums noted in the previous section represented a variety of art types, little attention was given to modern Japanese art. There were two main reasons for this deficiency. To begin with, the development of modern Japanese art had not yet reached the stage where collections were of much significance, and thus there was no collection of sufficient quality or size to constitute the basis for a museum. Again, the museums of the time concentrated on the public display of such art as they owned and were not yet active in promoting the appreciation of art. In a word, they had not attained the character of modern museums.

During the late Taisho and early Showa eras, three museums were established for the purpose of collecting and exhibiting modern art: the Tokyo Metropolitan Art Gallery in 1921, the Kyoto City Art Museum in 1933, and the Osaka Municipal Art Museum in 1936. None of these, however, successfully carried out its intended role. The Tokyo Metropolitan Art Gallery, even though it was nom-

inally given over to modern art, was perennially occupied in renting its space for government exhibitions and those of various art organizations. The Kyoto City Art Museum had something of a collection of modern art but not a large enough one for systematic permanent display. Nor was the museum competent to undertake any planned schedule of activities. Although the Osaka Municipal Art Museum had a large collection, ranging from old Oriental art to contemporary art, in prewar times its chief function was the renting of space for exhibitions other than its own. It was only in fairly recent years—in fact, after World War II —that the municipal museums of Kyoto and Osaka began to emerge as modern museums engaged in a positive course of activities.

POSTWAR ART MUSEUMS Art museums established after World War II are basically similar in origin to those of prewar times. But as art came to enjoy a more flourishing status in society at large, museums be-

144. Nagaoka Museum of Contemporary Art, Nagaoka, Niigata Prefecture. Opened in 1964.

145. Kanagawa Prefectural Museum of Modern Art, Kamakura. Opened in 1951.

came more constructive in character, engaging, for example, in such ventures as exhibitions sponsored by influential newspaper companies. To sum up the main postwar developments, museums of Western art and modern Japanese art have increased remarkably in number; there has been a similar increase in the number of museums engaged in a complex of activities centering on the display of their collections in specifically planned exhibitions; and a number of museums have been built in commemoration of individual artists.

Most temples and shrines that have long owned famous art objects have by now constructed museums or memorial halls for the purpose of displaying their treasures and charging admission to see them. In particular, temples that can no longer solely rely on their parishioners for their income have adopted this course, taking back the works of art they had lent to other museums and thereby attracting visitors to their own displays.

Private collectors and other persons of wealth and influence have established one important museum

after another during the postwar years, including the Homma Art Museum in Sakai, Yamagata Prefecture (1947); the Fujita Art Museum in Osaka (1951); the Bridgestone Museum of Art in Tokyo (1952); the Chido Museum in Tsuruoka, Yamagata Prefecture (1952); the Ishibashi Art Museum in Kurume, Fukuoka Prefecture (1956); the Atami Art Museum in Atami, Shizuoka Prefecture (1957); the Itsuo Art Museum in Ikeda, Osaka Prefecture (1957); the Goto (Gotoh) Art Museum in Tokyo (1960); the Yamato Bunkakan in Nara (1960); the Suntory Museum of Art in Tokyo (1962); and the Nagaoka Museum of Contemporary Art in Nagaoka, Niigata Prefecture (1964; Fig. 144). All these have become familiar to art lovers through their special programs as well as their collections. The Bridgestone Museum of Art and its sister gallery, the Ishibashi Art Museum, are known for their large collections of modern Western painting, the Yamato Bunkakan for its superior treasury of traditional Japanese art, and the Nagaoka Museum of Contemporary Art for its special attention to the

146. *Rokuzan Art Museum, Nagano Prefecture. Exterior and interior views. Opened in 1958.*

art of the present day. These are all new types of museums that did not exist in former years.

Because they are public institutions, it is usually difficult for prefectural and municipal art museums to own good collections, and they tend to confine their activities to the renting of their space for exhibitions by other organizations. Generally, these museums fall into two main types: those like the Tokyo Metropolitan Art Gallery, which engages chiefly in the rental of its facilities, and those like the Kyoto and Osaka municipal museums, which combine occasional rental arrangements with the display of their own collections. Museums of the first type include the Takamatsu Municipal Art Museum in Kagawa Prefecture, the Aichi Prefectural Cultural Center Art Museum in Nagoya, the Shimane Prefecture Art Museum in Matsue, and the Yawata Arts and Crafts Museum in Fukuoka Prefecture. Those of the second type are represented by the Ishikawa Prefectural Art Museum in Kanazawa and the Kagoshima Municipal Art Museum in Kagoshima Prefecture. The Kanagawa Prefectural Museum of Modern Art in Kamakura (Fig. 145) is unique in that it owns a collection of modern

Western and Japanese art and at the same time carries out significant activities on its own independent plan. It is a superlative example of the new local art museum.

In the years since the war, under the stimulus of the National Museum of Modern Art (1952) and the National Museum of Western Art (1959), it has become a common practice among museums to sponsor meaningful, well-planned loan exhibitions in addition to displaying their own collections. As we have previously noted, it is a distinctive feature of museums today that their activities, in comparison with those carried on in prewar times, have become far more constructive. Since more and more museums are being established throughout the country, it seems likely that in the future we shall have full-fledged local museums capable of following this new pattern.

Finally, let us look at a special type of art museum that has made its appearance since the war: the museum built to commemorate an individual artist and his works. Museums of this kind are not rare in Europe, where we find a large number of examples like the Rodin Museum in Paris, but in

prewar Japan there were hardly any at all besides the Kuroda Memorial Room at the Art Research Institute. After the war, however, a number of them came into existence. Regardless of their comparatively small size, they add a certain bright quality of their own to the museum scene in general. The outstanding ones among them are mentioned here: the Makino Memorial Hall (1950), for works by the Western-style painter Makino Torao (1890–1946); the Rokuzan Art Museum (1957; Fig. 146), for works by Ogiwara Morie; the Gyokudo Art Museum (1961), for works by Kawai Gyokudo; the Yamamoto Memorial Hall (1962), for works by the Western-style painter Yamamoto Kanae (1882–1946); the Ryushi Memorial Hall (1962), for works by Kawabata Ryushi; and the Ikeno Taiga Art Museum (1959), for works by the Edo-period artist Ikeno Taiga (1723–76).

It is difficult to inaugurate a museum dedicated to a single artist, for his works are likely to have been dispersed, but because of this very difficulty there is a greater appreciation of good museums of this kind. One hopes that the future will see more and more of them.

The "weathermark" identifies this book as a production of John Weatherhill, Inc., publishers of fine books on Asia and the Pacific. Supervising editor: Ralph Friedrich. Book design and typography: Meredith Weatherby. Layout of illustrations: Sigrid Nikovskis. Production supervisor: Yutaka Shimoji. Composition: General Printing Co., Yokohama. Color-plate engraving and printing: Mitsumura Printing Co., Tokyo, and Nissha Printing Co., Kyoto. Monochrome letterpress platemaking and printing and text printing: Toyo Printing Co., Tokyo. Binding: Makoto Binderies, Tokyo. The typeface used is Monotype Baskerville, with hand-set Optima for display.

TITLES IN THE SERIES

Although the individual books in the series are designed as self-contained units, so that readers may choose subjects according to their personal interests, the series itself constitutes a full survey of Japanese art and will be of increasing reference value as it progresses. The following titles are listed in the same order, roughly chronological, as those of the original Japanese editions. Those marked with an asterisk (*) have already been published or will appear shortly. It is planned to publish the remaining titles at about the rate of eight a year, so that the English-language series will be complete in 1975.

1. Major Themes in Japanese Art, by Itsuji Yoshikawa

*2. The Beginnings of Japanese Art, by Namio Egami

*3. Shinto Art: Ise and Izumo Shrines, by Yasutada Watanabe

*4. Asuka Buddhist Art: Horyu-ji, by Seiichi Mizuno

5. Nara Buddhist Art: Todai-ji, by Tsuyoshi Kobayashi

6. The Silk Road and the Shoso-in, by Ryoichi Hayashi

*7. Temples of Nara and Their Art, by Minoru Ooka

*8. Art in Japanese Esoteric Buddhism, by Takaaki Sawa

9. Heian Temples: Byodo-in and Chuson-ji, by Toshio Fukuyama

*10. Painting in the Yamato Style, by Saburo Ienaga

*11. Sculpture of the Kamakura Period, by Hisashi Mori

*12. Japanese Ink Painting: Shubun to Sesshu, by Ichimatsu Tanaka

*13. Feudal Architecture of Japan, by Kiyoshi Hirai

14. Momoyama Decorative Painting, by Tsuguyoshi Doi

*15. Japanese Arts and the Tea Ceremony, by T. Hayashiya, M. Nakamura, and S. Hayashiya

*16. Japanese Costume and Textile Arts, by Seiroku Noma

*17. Momoyama Genre Painting, by Yuzo Yamane

*18. Edo Painting: Sotatsu and Korin, by Hiroshi Mizuo

*19. The Namban Art of Japan, by Yoshitomo Okamoto

20. Edo Architecture: Katsura and Nikko, by Naomi Okawa

*21. Traditional Domestic Architecture of Japan, by Teiji Itoh

*22. Traditional Woodblock Prints of Japan, by Seiichiro Takahashi

*23. Japanese Painting in the Literati Style, by Yoshiho Yonezawa and Chu Yoshizawa

*24. Modern Currents in Japanese Art, by Michiaki Kawakita

25. Japanese Art in World Perspective, by Toru Terada

*26. Folk Arts and Crafts of Japan, by Kageo Muraoka and Kichiemon Okamura

*27. The Art of Japanese Calligraphy, by Yujiro Nakata

*28. The Garden Art of Japan, by Masao Hayakawa

*29. The Art of Japanese Ceramics, by Tsugio Mikami

30. Japanese Art: A Cultural Appreciation